Here Is My Kingdom

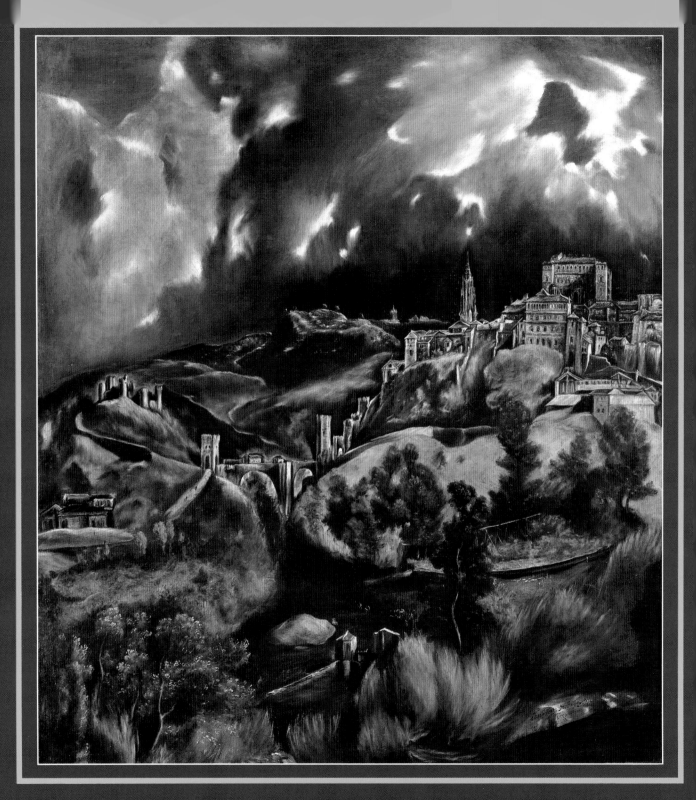

"They will drive me out, those last sentinels
still awake on the turrets; and they too inquire
who I am and where is my kingdom."
— Pedro Lastra

Here Is My Kingdom

Hispanic-American Literature and Art for Young People

Edited by Charles Sullivan

Foreword by Luis R. Cancel

This book is dedicated to the memory of
César Chávez (1927–1993)
and to those who follow him
for the harvest of justice and freedom:
Lo que siembra se recoje

Editor: Margaret Rennolds Chace
Designers: Carol Robson and Amy Gottlieb
Rights and Permissions: Neil Ryder Hoos

Library of Congress Cataloging-in-Publication Data

Here is my kingdom: Hispanic-American literature and art for young
people / edited by Charles Sullivan; foreword by Luis R. Cancel.
p. cm.
Includes index.
ISBN 0–8109–3422–1
1. Children's literature, American—Hispanic American authors.
2. Hispanic Americans in art—Juvenile literature. 3. Hispanic
Americans—Literary collections. 4. Hispanic Americans—Juvenile
literature [1. Hispanic Americans—Literary collections.
2. American literature—Hispanic American authors—Collections.
3. Hispanic Americans in art.] I. Sullivan, Charles, 1933– .
PS508.H57H47 1993 93-37412

Published in 1994 by Harry N. Abrams, Incorporated, New York
A Times Mirror Company

Printed and bound in Japan

On page 2:

View of Toledo, El Greco, about 1570

Toledo, Ohio, takes its name from this old Spanish city, and the artist
"El Greco" took his nickname from the country where he lived before
moving to Spain.

Foreword

The question of identity is a complex one for Spanish-speaking Americans. Some are descendant from families that have lived in the Southwest for centuries. Others are newly arrived to our shores and face the same challenges of adaptation that have confronted countless immigrant families before them. When Latinos look at each other they see Chicanos, Cubans, Guatematecos, Puerto Ricans, Venezuelans, Chileans, Mexican-Americans, and even Nuyoricans, a term coined to describe Puerto Ricans born and raised in New York City or elsewhere on the mainland United States. There are eighteen different Spanish-speaking countries in the Western hemisphere, and all of them, at one time or another, have sent some of their sons and daughters to try their luck in the United States.

It is therefore no wonder that the term "Hispanic" was coined here. The need to find a manageable label with which to handle such complexity has grown as the diversity of Spanish-speaking Americans has increased. The term Hispanic can blur the cultural distinctions, let's say, between Mexican-Americans, Puerto Ricans, and Cubans (to pick the three largest Spanish-speaking groups) and permit electoral coalitions to be built or census figures to be calculated. When it comes to personal identity, however, very few individuals would readily identify themselves as Hispanic. They would say they are Cuban or Dominican, or even a Tejano!

Communities establish unique characteristics through food, music, language, bonding rituals, and other elements of culture, such as literature and art. Most of the authors and artists included in *Here Is My Kingdom* reflect the diverse cultural origins that constitute Latinos in the United States. It is a point to keep in mind as you read this literature: though the authors often share a Spanish surname, they may each represent a different cultural heritage and community history. Some, like César Chávez, are the children of migrant farmworkers. When he proclaimed the beginning of the Farm Workers Union struggle for economic justice, this was similar to efforts by the Young Lords, in New York City, to secure political and economic power rights for Puerto Ricans. Other authors, like Odilia Galván Rodríguez, evoke the power of the arts to transform a sterile urban environment into a radiant symbol of peace. Some of these authors were political refugees searching for freedom; their literary works capture the hopes and aspirations shared by many new immigrants. Some writers, like Dave MartinNez, identify more closely with their indigenous cultural roots, while others draw upon their European or Afro-Caribbean backgrounds.

As you read the text selections, recognize, if you can, that you are only skimming the surface of a rich literary and historical tradition. As you gaze at the artwork, imagine that there are thousands of other Latino artists whose visions await your discovery. But most important, remember that the oral and literary traditions of your family, neighbors, and community can help you to define and celebrate your own unique identity. Latinos in this country have enormous potential—mostly due to the fact that so many of them are young and full of promise, but also because many long-held stereotypes about Latinos are falling by the wayside. Young readers of this anthology have as much right to distinguish what is a Latino as do the artists and authors represented on these pages. I hope *Here Is My Kingdom* inspires you to join in telling the story of what it means to be a Latino in America.

Luis R. Cancel
Commissioner of Cultural Affairs, New York City

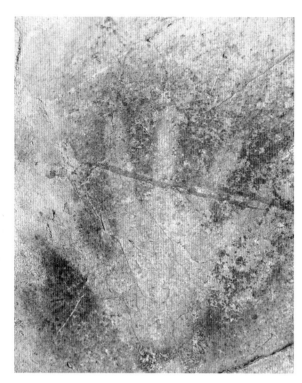

Outline of a hand, about 15,000 B.C.

Found in a cave near El Castillo, Santander, Spain. Who painted it there, so long ago—a man or a woman?

The Energy of Clay

Ray González

1

Of the hands, I say nothing.
The brown dirt embeds itself.
It sparks a dream out of the fingers.
I sink them into the moisture
and fall off the cliff
to find my father
at the bottom of the canyon,
digging with his bare hands,
molding clay figures of his daughters,
my mother, our house,
even as the rain
washes it all away
and covers him with the gray mud
of the one who can create anything.

2

Beyond the color of the sticky mud,
I gain wisdom to smear it
across my forehead,

paint my face as the son who slept
in the soil to find
the wanderings of the blood,
the gloves of mud that crack
into the palms we will follow
when we shape our first sculpture,
wake from the dream of hair and dirt
to go cut a fresh slab of clay
out of the heart of
the dry statue of my father.

3

In the caked daydream,
too many whispers that
the world will end in clay.
In the water splashed on the face,
then on the mound of clay—
a puddle, a mess, a reflection,
hands on a sculpture of a world
that gives up its rocks,
its adobe walls,
that wets the family down
so they can dissolve back to clay.

4

My mother said, "If you drink from the clay jar,
you can taste the desert."
She would look for tiny grains of dirt,
chips of the inner jar that fell in the water.
"If you crunch the dirt in your teeth,
you can taste the earth."
We drank from the jar,
inhaled the dark smell
of the cold water like
the odor of an undiscovered cave
somewhere beyond our house,
an underground spring
we dared to dig up,
the earthy taste of the jar
filling us with the need
to go down deeper,
to settle into the cave
like we had no choice—
our thirst meant we were
fated to go under,
never to look up at the sky,
always down to the ground
where the water jars sprang
like brown wombs of the mothers
quenching our thirst,
giving us our first taste of clay.

5

I come up and roll the dirt,
praise the new green color of clay
for being pure, but sharper
and hotter than the cactus
I tried to construct out
of the spreading clay.
I pound the soil like
the last traveler afraid water
from clay will not save him.
I push my palms together.
The face of the desert emerges
from my oozing hands.
The face of my father falls
into the cactus.

The faces of the rocks melt
into more clay.
The face of the sweetness of earth
takes shape from the clay ruins.
Then, the face of the clay-maker
turns green and dries into
the face of the dirt-dreamer.
And, the dirt-dreamer lifts
the clay into the face
of the clay jar that overflows with water.

6

Of the family, I know little.
They left to churn the mud
into a life they could accept.
Of my father, he lives in two worlds—
land of the canyon dweller,
and the hole of the clay,
territory he can never inhabit
because his adobe houses were
built from harder ground,
a mixture of the bitter cottonwood
and the pure acid of the thorn,
formed with the isolation
of the walls where all fathers,
in their son's clay dreams,
go and lie down to forget.

7

The sun bakes the clay without ovens,
gains the upper shadow
on the hard mud,
set into features by my fingers.
The sun goes down,
out of the way
of the clay-shaper who dreams alone
and digs in a new canyon
where the clay comes up
black and alive,
perfect for the fingers
where moisture seeps and obeys
the dreams of the masked hands.

What's a Knight Errant?

FROM THE NOVEL *Of the Ingenious Knight Don Quixote de la Mancha,* 1615
Miguel de Cervantes Saavedra

TRANSLATED BY CHARLES SULLIVAN

Sancho Panza and his master, bruised and tired from their adventures on the road, arrived at a small country inn and were kindly treated. But the young woman who worked there was curious about them.

"What's the gentleman's name?" she asked.

"Don Quixote de la Mancha," said Sancho Panza. "He is a knight errant—one of the best and bravest this world has seen for a long, long time."

"What's a knight errant?" she wanted to know.

"Are you so ignorant you don't know that?" Sancho answered. "Then I'll tell you, young lady, that a knight errant—leaving out the details—is beaten up one day and made Emperor the next. Today he's the poorest fellow in all the world; but tomorrow he'll have two or three kingdoms to give to his faithful servant."

A Popular History of Mexico, mural by Diego Rivera on the Teatro de los Insurgentes, Mexico City, 1953

Playing at the theater later was *Man of La Mancha,* a musical drama based on Cervantes's story about Don Quixote.

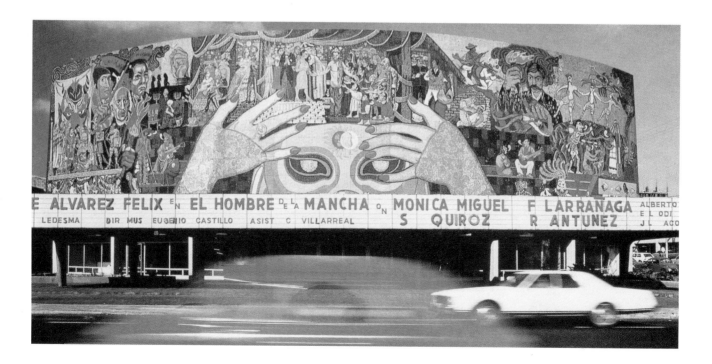

Silence Near an Ancient Stone

Rosario Castellanos

TRANSLATED BY MAUREEN AHERN

I'm sitting here with all my words
like a basket of green fruit, intact.

The fragments
of a thousand ancient and defeated gods
seek and bind each other in my blood, straining
to rebuild their statue.
From their shattered mouths
a song struggles to rise to mine,
an aroma of burnt resin, some gesture
of mysterious carved stone.
But I am oblivion, betrayal,
the shell that did not hold an echo
from even the smallest wave in the sea.
I do not watch the submerged temples;
I watch only the trees moving their vast shadows
over the ruins, biting the passing wind
with acid teeth.
And the signs close beneath my eyes like
a flower under the awkward fingers of the blind.
Yet I know: behind
my body another body crouches,
and around me many breaths
cross furtively
like nocturnal animals in the jungle.
I know that in some place
the same
as the cactus in the desert,
a clustered heart of thorns, awaits a name
as the cactus does the rain.
But I know only a few words
in the language of the stone
beneath which they buried my ancestor alive.

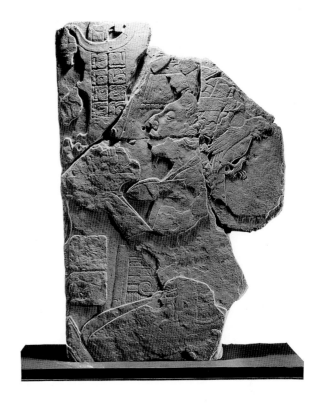

Mayan Figure (Jonuta Tablet),
photograph by Irmgard Groth-
Kimball, 1965

The Mayan people created many
mysterious sculptures in southern
Mexico and Central America.

I Just Lightning

Maria Sabina

PART OF A CHANT
TRANSLATED FROM THE MAZATEC LANGUAGE INTO SPANISH BY ELOINA ESTRADA DE GONZÁLEZ, AND
FROM SPANISH INTO ENGLISH BY HENRY MUNN

I just lightning, says
I just shout, says
I just whistle, says
I am a lawyer woman, says
I am a woman of transactions, says
Holy Father, says
That is his clock, says
That is his lord eagle, says
That is his opossum, says
That is his lord hawk, says
Holy Father, says
Mother, says
I am a mother woman beneath the water, says
I am a woman wise in medicine, says
Holy Father, says
I am a saint woman, says
I am a spirit woman, says
She is woman of light, says
She is woman of the day, says
Holy Father, says
I am a shooting star woman, says
I am a shooting star woman, says
I am a whirling woman of colors, says
I am a whirling woman of colors, says
I am a clean woman, says
I am a clean woman, says
I am a woman who whistles, says
I am a woman who looks into the insides of things, says
I am a woman who investigates, says
I am a woman wise in medicine, says
I am a mother woman, says
I am a spirit woman, says
I am a woman of light, says
I am a woman of the day, says
I am a Book woman, says
I am a woman who looks into the insides of things, says

Chants and Music (detail),
Rufino Tamayo, 1933

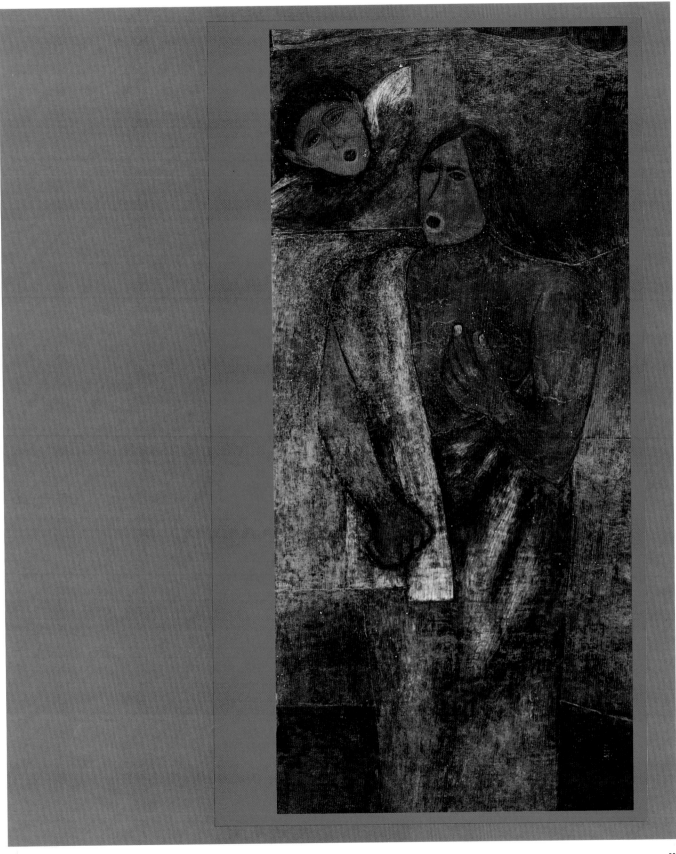

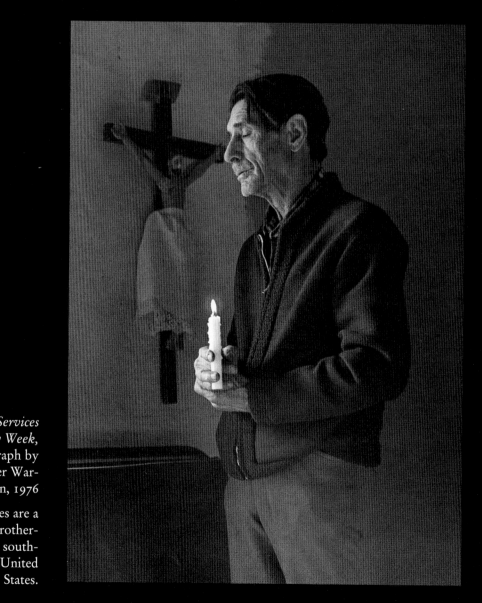

Penitente Services during Holy Week, photograph by Nancy Hunter Warren, 1976

The Penitentes are a Catholic brotherhood in the southwestern United States.

In the Beginning

EXCERPT FROM SHORT STORY "THE PENITENTES"
Sabine R. Ulibarrí

In the beginning there was no government in these lands, no church, no school. The people did what they could with what they had and with what they didn't have.

The Brotherhood of the Penitentes was the only group with authority, the only disciplined organism, in the isolated villages, abandoned first by Spain, later Santa Fe and Mexico, and finally by the United States.

In the farthest corner of the civilized world, in this isolation, in this abandonment and almost total neglect our New Mexicans could have ended in a state of barbarism. They could have lost their language, their religion and their traditions. They could have lost their civilized ways. They could have stopped being Hispanos. None of these things happened. After four hundred years Hispanic culture remains live and alert, and the New Mexican is as Hispano today as he was in those days.

The Penitentes more than anyone filled the administrative, religious, and cultural vacuum. Being the only organized structure where there was no official government they took the initiative in establishing the guidelines of government for the community, and the strong arm of the Brotherhood was always available to maintain public order, the defense of the village and to provide help in disasters. They also provided great political service. The Brotherhood was large and had branches in every town. This served to establish communication, harmony and union among the diverse and scattered villages.

In a world without priests, the Penitentes kept the religion unblemished. They were the ones who instructed the people in the prayers, the ceremonies, the sacraments, the mysteries and the hymns of the Church. They had the books and the manuscripts. Through the religious exercises they kept the language alive and relatively pure. Perhaps we owe in large measure that mysticism so characteristic of our people to the Penitentes. So who knows how many New Mexicans have gone to Heaven and have introduced themselves to Saint Peter in perfect Castilian, thanks to the Penitentes.

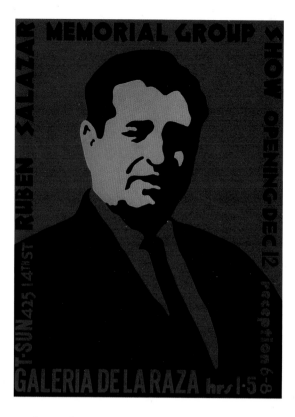

Rubén Salazar Memorial,
poster by Rupert Garcia, 1970

Salazar, a journalist who often wrote about
Chicanos for the *Los Angeles Times,*
was accidentally killed during the riots of 1970.

Who Is a Chicano?

EXCERPT FROM NEWSPAPER ARTICLE, *Los Angeles Times*, FEBRUARY 6, 1970
Rubén Salazar

A Chicano is a Mexican-American with a non-Anglo image of himself.... What, then, is a Chicano? Chicanos say that if you have to ask you'll never understand, much less become a Chicano.

When They Ask Me for My Nationality

FROM ESSAY "DOCUMENTED/UNDOCUMENTED"
Guillermo Gómez-Peña

Today, eight years after my departure [from Mexico], when they ask me for my nationality or ethnic identity, I can't respond with one word, since my "identity" now possesses multiple repertories: I am Mexican but I am also Chicano and Latin American. At the border they call me *chilango* or *mexiquillo;* in Mexico City it's *pocho* or *norteño;* and in Europe it's *sudaca.* The Anglos call me "Hispanic" or "Latino," and the Germans have, on more than one occasion, confused me with Turks or Italians. My wife Emilia is Anglo-Italian, but speaks Spanish with an Argentine accent, and together we walk amid the rubble of the Tower of Babel of our American post-modernity.

Undocumented, Malaquias Montoya, 1981

Being "undocumented" means not having
the official papers needed to move freely
from one country to another.

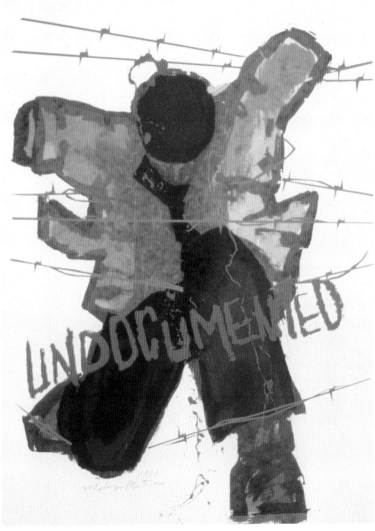

Border Towns

Roberto Durán

Border towns and brown frowns
and the signs say
get back wet back
souls are searched at night by silver flashlights
gringos and greasers play cat and mouse
and I still wonder why
do apple pies lie?
the signs say live the american way
visit but don't stay
be a friendly neighboor hire good cheap labor
as rows and rows of illegal star war aliens
are aligned and maligned
as the morning shouts fill the morning chill and still
they will not
no way José go away

The Other
Judith Ortiz Cofer

A sloe-eyed dark woman shadows me.
In the morning she sings
Spanish love songs in a high
falsetto, filling my shower stall
with echoes.
She is by my side
in front of the mirror as I slip
into my tailored skirt and she
into her red cotton dress.
She shakes out her black mane as I
run a comb through my closely cropped cap.
Her mouth is like a red bull's eye
daring me.
Everywhere I go I must
make room for her; she crowds me
in elevators where others wonder
at all the space I need.
At night her weight tips my bed, and
it is her wild dreams that run rampant
through my head exhausting me. Her heartbeats,
like dozens of spiders carrying the poison
of her restlessness,
drag their countless legs
over my bare flesh.

With What Voice?
FROM "NOT NEITHER"
Sandra María Esteves

Being Puertorriqueña Americana
Born in the Bronx, not really jíbara
Not really hablando bien
But yet, not Gringa either
Pero ni portorra, pero sí portorra too
Pero ni qué what am I?
Y que son, *pero con what* voice do my lips
move?

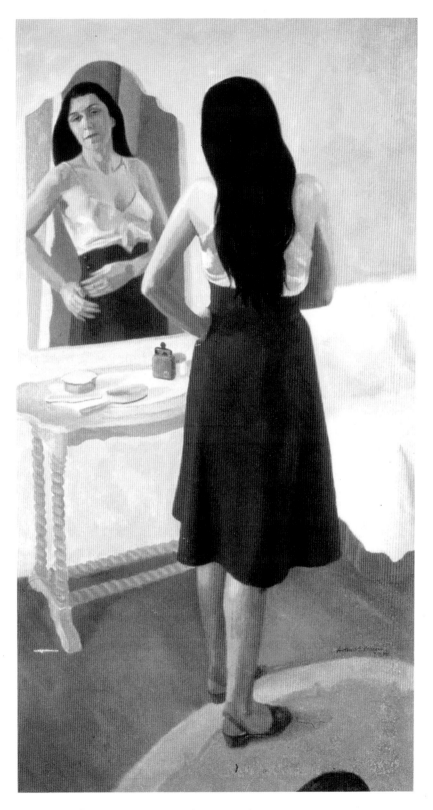

Woman Before a Mirror, Antonio E. Garcia, 1939

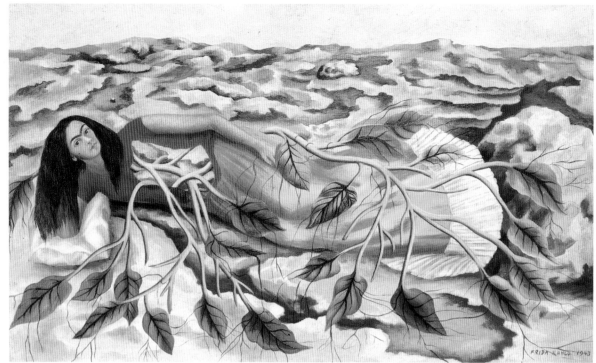

Roots, Frida Kahlo, 1943

We Are an Old People

FROM "THE ROOTS"
Hugo Salazar Tamariz

TRANSLATED BY DARWIN J. FLAKOLL AND CLARIBEL ALEGRÍA

We are an old people,
 the earth is ours,
we love it,
 and stretch to embrace it,
 face downwards,
with all our hunger
 and our children.
We have been,
 and we continue, inside the clod
that plows renew,
 and in the high fruit.
An old people not grown old, we have a multitude of light
and of grass,
 growing;
 of doors
 and windows,
 opened.

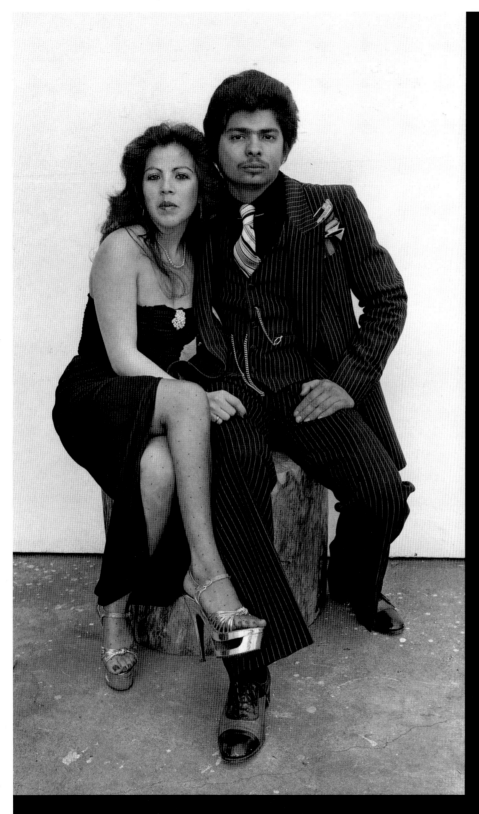

Lowrider Couple, photograph by Joe B. Ramos, 1980

"Lowriders" are cut-down, dressed-up cars, preferably 1950s models, whose owners (also known as "lowriders" in some places) take great pride in displaying the results of their artistry.

Trendy Categorization
Roberto Durán

Hispanic
Herpanic
Hispanic
Herpanic
Hispanic
Herpanic
Hispanic
Herpanic
Hispanic
Herpanic
Hispanic
Herpanic
Hispanic

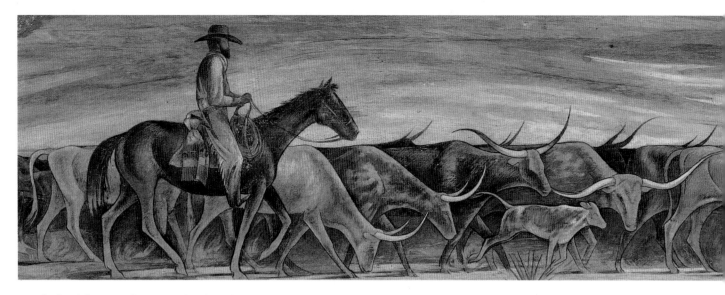

Study for *The Longhorn Trail*, Eduardo Chávez, 1938
Hard-working *vaqueros* showed other cowboys the best way to do the job.

Five Hundred Steers There Were

FROM FOLK SONG

TRANSLATED BY AMÉRICO PAREDES

Five hundred steers there were, all big and quick;
thirty American cowboys could not keep them bunched together.

Then five Mexicans arrive, all of them wearing good chaps;
and in less than a quarter-hour, they had the steers penned up.

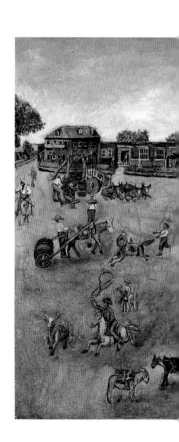

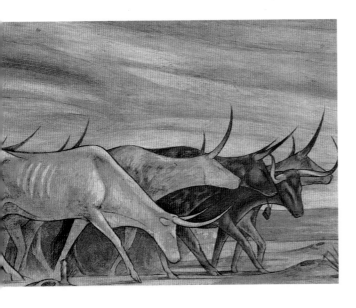

West Side Main Plaza, San Antonio, Texas, William G. M. Samuel, 1849

In the mid-nineteenth century, the people of San Antonio seemed to be getting along well together. Why did things change?

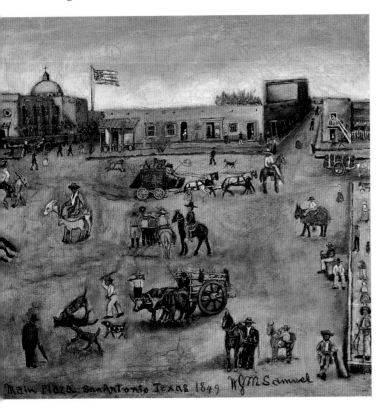

San Antonio

Carmen Tafolla

San Antonio,
 They called you lazy.
They saw your silent, subtle, screaming eyes,
 And called you lazy.
They saw your lean bronzed workmaid's arms,
 And called you lazy.
They saw your centuries-secret sweet-night song,
 And called you lazy.

San Antonio,
 They saw your skybirth and sunaltar,
 Your corn-dirt soul and mute bell-toll,
 Your river-ripple heart, soft with life,
 Your ancient shawl of sigh on strife,
 And didn't see.
San Antonio,
 They called you lazy.

The Power of Man

Raquel Jodorowsky

TRANSLATED BY PAMELA CARMELL

When the force of man
calms down
stops its machines
puts away arms
A silence swells
in which I hear
the light of the Moon.
A chemical silence
in which I see sounds
from the beginnings of Earth.

In this, I feel growing
the spine of time
crackling like broken insects.
These are hours
apart from the hours
when I start to balance myself
on the horizon.
On the edge of the planet
I capture poetry
dictated in other orbits.
It is not the stillness of nature
in which animals sing or call to each other.
It is the silence of the mind
that leads us
to the magic of the World.

Camas para Sueños (Beds for Dreams),
Carmen Lomas Garza, 1985

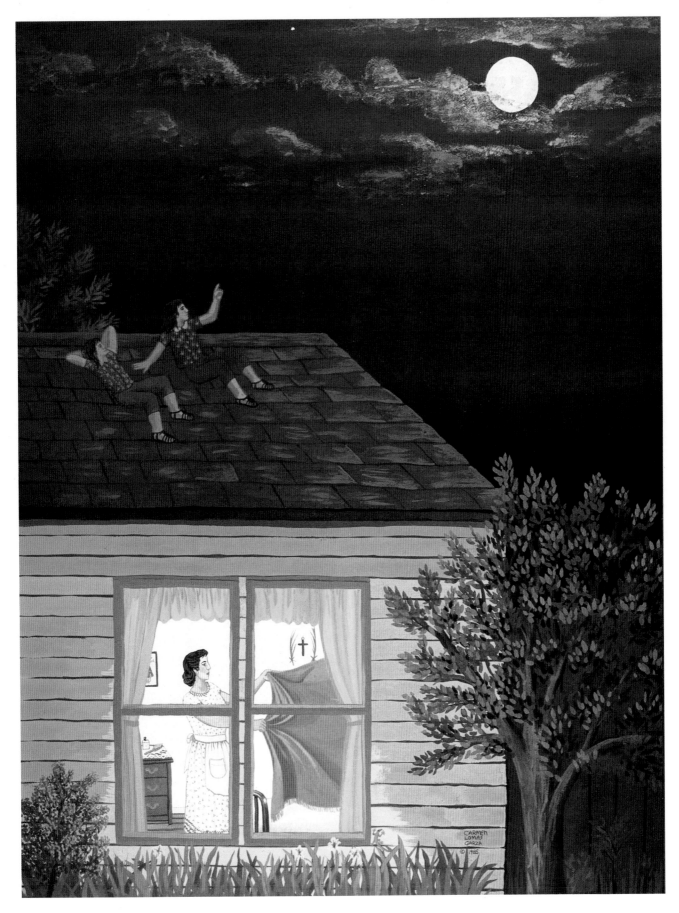

The Summer of Vietnam

Barbara Renaud González

So, what are you writing about? I ask Bill Broyles, the former *Newsweek Magazine* goldenboy. He's the Texas man who can write *anything* and get it published. Unlike me.

"Vietnam," he says. The worst answer. The only answer that can make me cry.

Instead, at night I remember.

Ernesto Sánchez is Vietnam to me. Born July 9, 1947. In a place called Kennedy, Texas. Died in the summer of 1967, somewhere in Vietnam. Somewhere in my 13th summer.

This is my Vietnam.

I sang love songs to them. Made up Ken dolls after them. Imagined kissing them. I still do. Marine-boys. Boys in dress green with stiff brass buttons that would catch your breaking heart when they gave you the biggest *abrazo* of your life. Then they died in Vietnam.

Always teasing me. "This last dance is for you, Barbara," they'd say. Taught me to dance those skip-steps of adolescence. Told me they'd wait for me. And they never came back from Vietnam to see how I'd grown up for them.

I knew they would not die. Heroes don't die in the movies, after all. The good guys always win. Who would dare extinguish the crooked smiles, football hands and Aqua Velva faces I knew so well? My brothers-at-war.

Of the 3,427 Texas men who died in Vietnam, 22 percent were Latinos. And another 12 percent of the dead were African-American. The minorities were *not* a minority in the platoons, but a majority of the frightened faces. And one-third of the body bags

This at a time when Latinos constituted 12 percent of the population.

But the machismo goes a long way in war. We Latinos received more medals, thirteen of the prestigious Medal of Honor, than any other group.

We can count soldiers in the American Revolution (as Spaniards), the Roosevelt Rough Riders, both sides of the Civil War, and plenty of fathers and abuelitos in the world wars. Soldiering doesn't require U.S. citizenship, and no one cares how you crossed the border if you're willing to fight on our side.

We lost our best men in Vietnam. Isaac Camacho died first in 1963. Everett Alvarez was the first American pilot shot down, spending eight-and-a-half years as a POW. Juan Valdez was in the last helicopter leaving Vietnam. First in, and last out. They didn't go to Canada or Mexico. They went directly to Vietnam.

But from Oliver Stone, you would think that all our boys looked like Tom Cruise. Or agonized at China Beach. No. They were my brothers, uncles, cousins, my heroes.

Sometimes it looks as if they died for nothing. Impossible. It cannot be. Blood lost is blood redeemed, they say. What is the boy worth? If he died for all of us, then we must gain in proportion to the sacrifice. A Medal of Honor for the neighborhood school. Some Distinguished Service Crosses for family housing. Maybe the Bronze Stars for the judge or councilman. Flying Crosses for a good job. And a Purple Heart for a mother who still cries in Spanish.

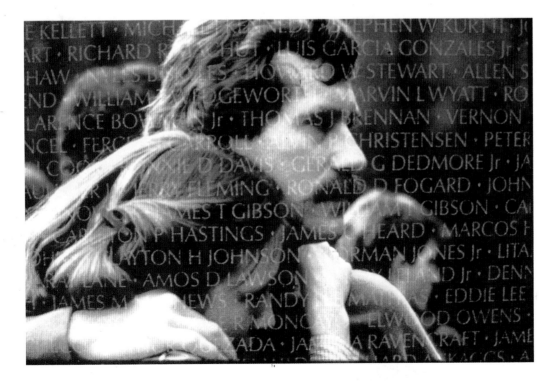

And We Remember, photograph at the Vietnam War Memorial, Washington, D.C., by Robert B. Baker

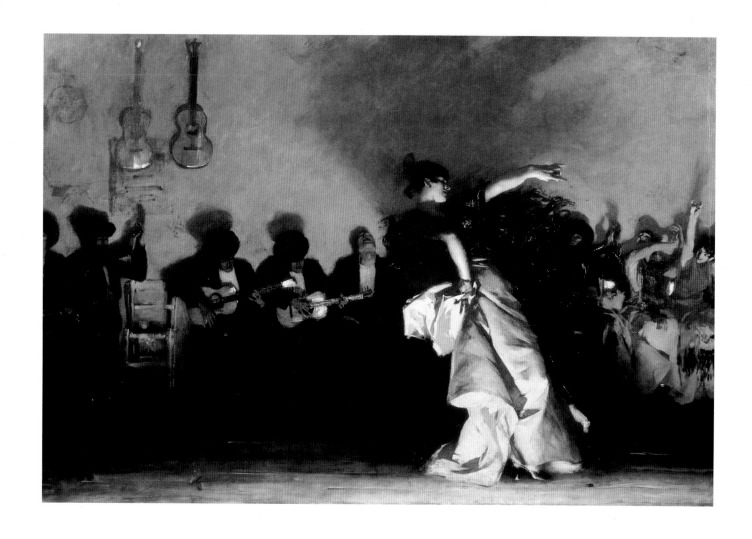

Queen of the Gypsies

FROM SHORT STORY "CREASE"
Lisa Sandlin

I hauled myself out of the armchair and walked into the bathroom. I began to do footwork patterns on the black and white tile. Though I was not dancing lightly, the sounds were sharp, weightless. I went on and on, doing step after step from my *soléa.* Ray has an original Queen of the Gypsies album, the one on which Carmen Amaya recorded her inhuman *alegrías,* rolling rhythm after crushing rhythm, counter matched by counter-rhythm to the sole accompaniment of clapping hands. No guitar, no song, just the steady palms and an occasional shout of encouragement. Carmen Amaya danced the *silencio* for an eternity of fourteen minutes. I stopped to take a very deep breath. Then, gathering the skirt to my side, I cradled the ruffles and started the footwork again. I was realizing that, while she danced it, it must have felt to Carmen that that *silencio* could go on forever.

El Jaleo, John Singer Sargent, 1882

A classic picture of traditional Andalusian dancing with guitars and castanets, seen by the artist during a trip to Spain. The title *El Jaleo* means "an uproarious good time," something like the English word "hullabaloo."

Caballito, Caballito

FOLK RHYME

TRANSLATED BY CHARLES SULLIVAN

Caballito, caballito
no me tumba, no me tumba
a galope y a galope
recio, recio, recio
¡Qué viva Antonio!

Little pony, little pony,
do not throw me, do not throw me—
galloping and galloping,
I bounce, I bounce, I bounce—
Long live Antonio!

Push toy from North Central Mexico, artist unknown, 1930s

This Isn't Middle America

FROM "TO MR. GABACHO 'MACHO'"
Carmen Tafolla

No, this isn't Middle America
or even upper lower…
…It's barrio town we're walkin' through
And your watch is runnin'
 slower.

There's hunger here and anger too,
and insult and frustration.
There's words you never heard about
like Gacho Agui-tay-shun.

No, Gacho isn't Macho
and we don't all carry knives
And our women don't all go to mass
nor our men all beat their wives.

Our men head more than welfare lines
And our women aren't so timid
And we don't steal fritos from your bowl
Or test Arrid to the limit.

Here "chili" isn't a dish with beans
It's a concentrated bowl of salsa
And my sister isn't pregnant
even though she *is* descalza.

The only sombreros I ever saw
were on the heads of tourists
and the girl with a rose between her teeth
is working as a florist.

And no, "te aguitaste"
doesn't mean that you drank water
And "Cuidado, porque me caliento"
doesn't mean it's getting hotter.

A project here's not what you *do*
It's where you *live,* and trust us—
when we talk about "los courts,"
we don't mean "centers of justice."

Sometimes you get the feelin'
we know this nation better'n you?
Well, Lordy me—how smart you be!
Cause that just might be true!

This is a different language, vato,
And you better learn it quick
Cause you see, Mr. Gabacho "Macho,"
This woman here's
 a spic.

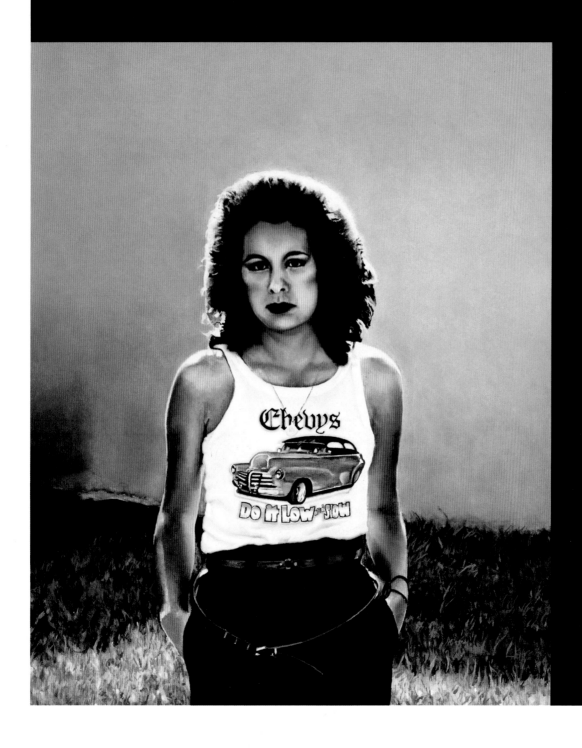

Home Girl #1, Daniel Galvez, 1983

Who Are You?

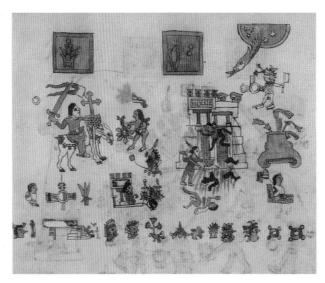

Cortés Arriving in the Ancient Capital of Mexico,
anonymous Aztec artist, about 1519–22

An eyewitness picture of the same scene described by the Spanish historian,
with Moctezuma (or Montezuma), the Aztec king, presenting a golden necklace
to the conqueror, Hernán Cortés.

As Soon As We Arrived

FROM BOOK *The Discovery and Conquest of Mexico, 1517–21*
Bernal Díaz del Castillo

TRANSLATED BY A. P. MAUDSLAY

As soon as we arrived and entered into the great court, the Great Montezuma took our Captain by the hand, for he was there awaiting him, and led him to the apartment and saloon where he was to lodge, which was very richly adorned according to their usage, and he had at hand a very rich necklace made of golden crabs, a marvellous piece of work, and Montezuma himself placed it round the neck of our Captain Cortés, and greatly astonished his [own] Captains by the great honour that he was bestowing on him. When the necklace had been fastened, Cortés thanked Montezuma through our interpreters, and Montezuma replied—"Malinche, you and your brethren are in your own house, rest awhile," and then he went to his palaces, which were not far away, and we divided our lodgings by companies, and placed the artillery pointing in a convenient direction, and the order which we had to keep was clearly explained to us, and that we were to be much on the alert, both the cavalry and all of us soldiers. A sumptuous dinner was provided for us according to their use and custom, and we ate it at once. So this was our lucky and daring entry into the great city of Tenochtitlan Mexico on the 8th day of November the year of our Saviour Jesus Christ, 1519.

Juan Manuel Marcilla de Tereul Moctezuma and Princess Maria Gloria Pignatelli D'Aragona Cortés
on the Steps of the Pyramid of the Sun in Teotihuacán, near Mexico City,
photograph by Tom Hollyman, 1992

The descendants of Moctezuma and Cortés can meet today in peace.

Years of Fear, Roberto Matta, 1941

You Walk Inside Yourself

FROM "THE HOUSE OF GLANCES"
Octavio Paz

TRANSLATED BY ELIOT WEINBERGER

for Roberto Matta

You walk inside yourself, and the tenuous, meandering reflection that guides you
is not the last glance of your eyes before closing, nor the timid sun that beats
your lids:
it is a secret stream, not of water but of pulse-beats: calls and answers and calls,
a thread of clarities among the tall grasses and the beasts of the mind that crouch in the
darkness.
You follow the murmur of your blood through the unknown territory your eyes invent,
and you climb a stairway of glass and water, up to a terrace.
Made of the same intangible material as echoes and clanging,
the terrace, suspended in
air, is a rectangle of light, a magnetic ring
that wraps around itself, rises, walks, and plants itself in the
circus of the eye,
a lunar geyser, a stalk of steam, a foliage of sparks, a great tree that lights up, goes out
lights up:
you are in the interior of the reflections, you are in the house
of glances,
you have closed your eyes, and you enter and leave from
yourself to yourself on a bridge
of pulse-beats:
 THE HEART IS AN EYE.

Love or Cult

Hjalmar Flax

Others
will find the answer.
In time of adversity we
will maintain
our faith.

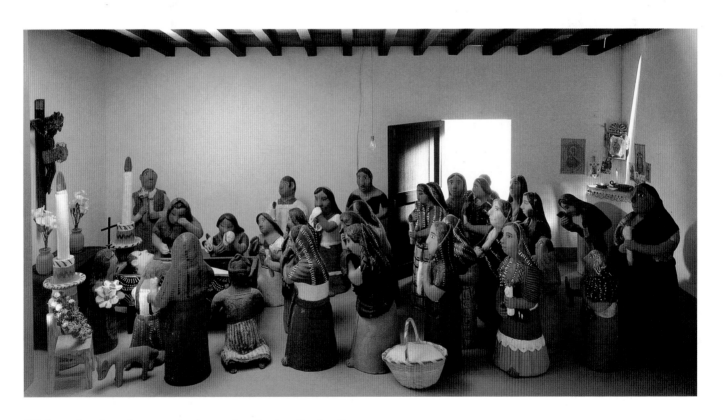

Wake, painted earthenware sculpture by the Aguilar family,
Oaxaca, Mexico, about 1960

So That They Will Burn

Rita Geada

TRANSLATED BY DONALD D. WALSH

So that all the world's lies will burn
I must burn.
So that the flames will destroy themselves
you must burn.
A span is missing.
Only a single span.
Leaping.
Reaching it we can see
the skeleton
of all the lies in the world.

Tactical Police Force, Luis Jimenez, 1969

This is how one artist reacted to the Los Angeles riots of 1968.

Uncertain Admission

Frances Bazil

The sky looks down on me in aimless blues
The sun glares at me with a questioning light
The mountains tower over me with uncertain shadows
The trees sway in the bewildered breeze
The deers dance in perplexed rhythms
The ants crawl around me in untrusting circles
The birds soar above me with doubtful dips and dives
They all, in their own way, ask the question,
Who are you, who are you?
I have to admit to them, to myself,
I am an Indian.

"We've thought and thought, but we're at a loss about what to call ourselves. Any ideas?"

Cartoon by J. B. Handelsman, 1992

The cartoonist treats a serious subject—the first encounter between Native Americans and the Europeans who "discovered" and named them—in a humorous way. Almost five centuries later, the poet (a young Indian girl in Arizona) answers the same question.

Now They Are All Going to Cuba to War Against the Spaniards

FROM A LETTER BY THEODORE ROOSEVELT TO HIS CHILDREN,
MAY 6, 1898, TAMPA, FLORIDA

We were all, horses and men, four days and four nights on the [railroad] cars coming here from San Antonio, and were very tired and very dirty when we arrived. I was up almost all of each night, for it happened always to be at night when we took the horses out of the cars to feed and water them.

Mother stays at a big hotel about a mile from camp. There are nearly thirty thousand troops here now, besides the sailors from the war-ships in the bay. At night the corridors and piazzas are thronged with officers of the army and navy; the older ones fought in the great Civil War, a third of a century ago, and now they are all going to Cuba to war against the Spaniards. Most of them are in blue, but our rough-riders are in brown. Our camp is on a great flat, on sandy soil without a tree, though round about are pines and palmettos. It is very hot, indeed, but there are no mosquitoes. Marshall is very well, and he takes care of my things and of the two horses. A general was out to inspect us when we were drilling to-day.

Charge of the 24th and 25th Colored Infantry and Rescue of Rough Riders at San Juan Hill, Cuba, July 2nd, 1898, artist unknown

This was the legendary battle in which U.S. soldiers helped to end Spain's control of Cuba and other colonies. Roosevelt's "Rough Riders" led the charge, but were almost wiped out. He became a war hero, later President of the United States.

Sometimes All You Want

Gustavo Pérez-Firmat

Sometimes all you want
is the peacefulness of Wednesday nights,
our sofa,
the door half open to hear
the night and exorcise my holy smoke.

No roads or inroads
no ventures or adventures
content with my limitation,
my occasional Armani tie
and Miami.

Sometimes not enough
is good enough.
Sometimes not enough
is all you could ever want.

The Lovers, Rufino Tamayo, 1943

Guatemala City, Guatemala, photograph by Sebastião Salgado, 1978

Love Is the Other 2 Per Cent

FROM SPEECH "UNITED FRUIT IS NOT CHIQUITA"
Nathaniel Davis, U.S. Ambassador to Guatemala,
addressing the U.S. Chamber of Commerce meeting in
Guatemala, April 20, 1971

Money isn't everything. Love is the other 2 per cent.
I think this characterizes the United States' relationship
with Latin America.

Mexico Is Sinking

Guillermo Gómez-Peña

Mexico is sinking
California is on Fire
& we all are getting burned
aren't we?
But what if suddenly the continent turned upside down?
what if the U.S. was Mexico?
what if 200,000 Anglo-Saxicans
were to cross the border each month
to work as gardeners, waiters,
3rd chair musicians, movie extras,
bouncers, babysitters, chauffeurs,
syndicated cartoons, feather-weight boxers, fruit-pickers, &
anonymous poets?
what if they were called waspanos,
waspitos, wasperos or waspbacks?
what if we were the top dogs?
what if literature was life, eh?
what if yo were you
& tú fueras I, Mister?

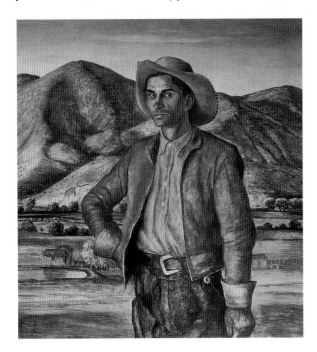

José Herrera, Peter Hurd, 1938

Where Have We Come From?

Femme Violet (Woman in Violet),
Wifredo Lam, 1938

The artist, of Afro-Cuban ancestry,
has drawn a woman's face to look
like an African mask of carved
wood.

Seeing Snow

Gustavo Pérez-Firmat

Had my father, my grandfather, and his,
had they been asked whether I would ever see snow,
they certainly—in another language—
would have answered,
no. Seeing snow for me
will always mean a slight or not so slight
suspension of the laws of nature.
I was not born to see snow.
I was not meant to see snow.
Even now, snowbound as I've been
all these years,
my surprise does not subside.
What, exactly, am I doing here?
Whose house is this anyway?
For sure one of us has strayed.
For sure someone's lost his way.
This must not be the place.
Where I come from, you know,
it's never snowed:
not once, not ever, not yet.

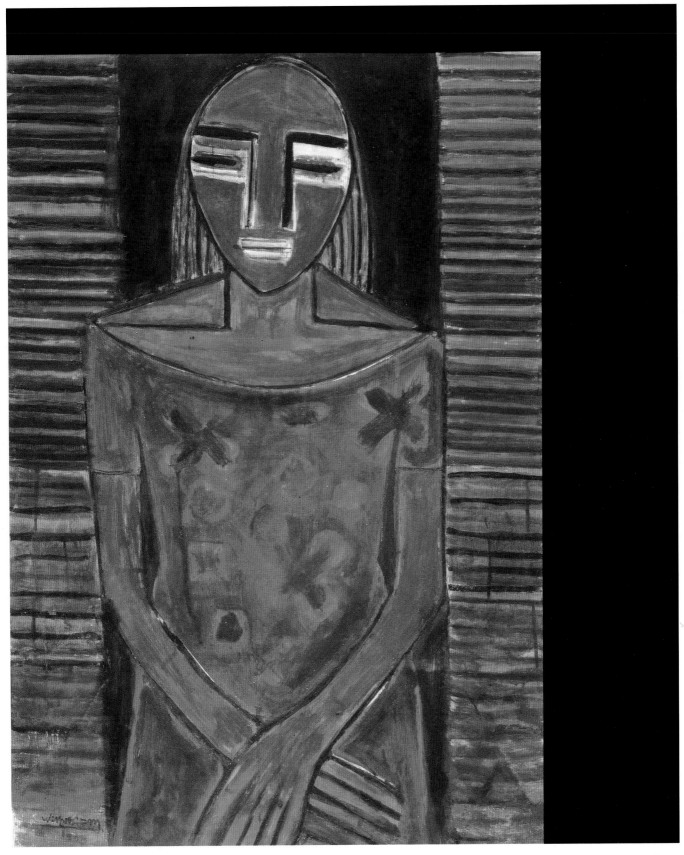

At the First Island I Discovered I Seized Some Natives

From letter by Christopher Columbus to King Ferdinand and Queen Isabella of Spain, 1493, describing his discoveries

TRANSLATED BY J. M. COHEN

I gave them a thousand pretty things that I had brought, in order to gain their love and incline them to become Christians. I hoped to win them to the love and service of their Highnesses and of the whole Spanish nation and to persuade them to collect and give us of the things which they possessed in abundance and which we needed. They have no religion and are not idolaters; but all believe that power and goodness dwell in the sky and they are firmly convinced that I have come from the sky with these ships and people. In this belief they gave me a good reception everywhere, once they had overcome their fear; and this is not because they are stupid—far from it, they are men of great intelligence, for they navigate all those seas, and give a marvellously good account of everything—but because they have never before seen men clothed or ships like these.

As soon as I came to the Indies, at the first island I discovered I seized some natives, intending them to inquire and inform me about things in these parts. These men soon understood us, and we them, either by speech or signs and they were very useful to us. I still have them with me and despite all the conversation they have had with me they are still of the opinion that I come from the sky and have been the first to proclaim this wherever I have gone. Then others have gone running from house to house and to the neighbouring villages shouting: "Come, come and see the people from the sky," so, once they were reassured about us, all have come, men and women alike, and not one, old or young, has remained behind. All have brought us something to eat and drink which they have given with a great show of love.

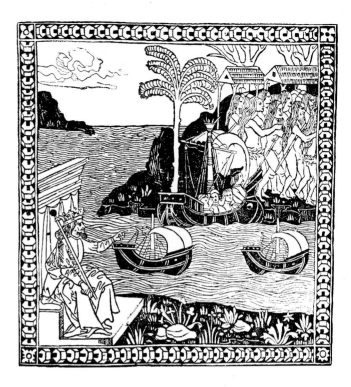

King Ferdinand Points to Columbus Landing in the New World, artist unknown, 1493

An illustration for the letter that Columbus wrote to the king and queen of Spain.

Drawbridges

Pedro Lastra

Who is this monarch without scepter or crown
lost in the middle of his palace?
The innocent pages are no longer present
(now each one is fighting for a kingdom
and yet unowned). The ladies of the court
prepare for exile.
To whom then belongs this incompetent
hand, these eyes that see only vague
frontiers or the wind
that scatters the remains of the banquet?
I've come too late, I have
nothing to do here,
I didn't recognize the drawbridges
and that one in front of me
wasn't the one that I sought.
They will drive me out, those last sentinels
still awake on the turrets; and they too inquire
who I am and where is my kingdom.

Proverb

TRANSLATED BY CHARLES SULLIVAN

No todo lo que brilla es oro.

Not everything that shines is gold.

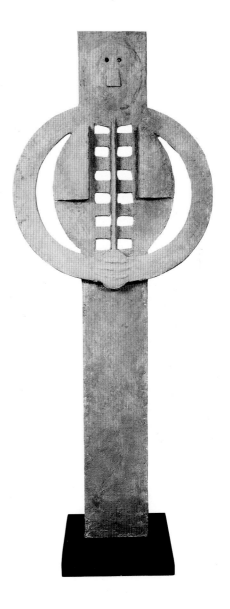

Figura Sideral (Space Figure),
Rufino Tamayo, 1989

43

Emigrant to America
Vicente Huidobro

Electric stars
Burn in the wind

 And certain astrological signs
 Have fallen into the sea

 This emigrant that sings
 Will set out tomorrow

To live
 To seek

Tied up to the ship

 Like a horoscope
Twenty days on the sea

Beneath the waters
Swim vegetable octopuses

Beyond the horizon
 The other harbor

Among the bushes
Roses without leaves

 Illuminate the streets

Lost Port
Gonzalo Rojas

All is narrow and deep
in this weightless earth, flowers
grow on knives, face down on the sand
one can hear a volcano; when the rain
moistens it, the mystery
clears up, a fantastic
chair appears in the heavens,
and seated there the God of lightning
like an aged mount of snow.

All is narrow and deep, persons
leave no trace, for the wind
casts them to their north and nothingness,
so that
suddenly
I go out on my balcony and no longer see anyone,
I see neither house nor blond women,
the parks have disappeared,
everything is invulnerable sand, all
was illusion, there was
no one on this bank of the planet
before the wind.

Then I run towards the sea, I sink
in its kiss, birds
form a sun on my forehead,
then I take possession of the air and the momentary rocks
in name of the wind, the blue stars,
Valparaiso, the wind.

Nocturne in Blue and Gold: Valparaíso Bay, James McNeill Whistler, 1866

The port of Valparaíso, Chile, was unforgettably beautiful to this visiting artist.

Guernica, Pablo Picasso, 1937

Picasso tried to show in one huge painting the agony of a village destroyed by bombing during the Spanish Civil War.

Civil War: Spain
Roberto Lima

TRANSLATED FROM SPANISH BY THE AUTHOR

LONG LIVE DEATH!

The charge

 across the torn geography

The feet

 once warm, now lying cold and still

The lives

 prone each upon the side of strife

The sky

 blood-red in the refracted light

LONG LIVE DEATH!

The cry

 redundant on the crimson earth

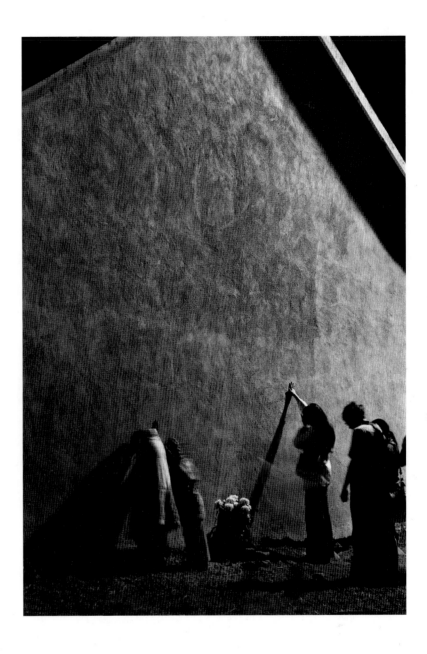

An Apparition Has Appeared on the Wall of the Church

FROM SHORT STORY
"ILIANA OF THE PLEASURE DREAMS"
Rudolfo A. Anaya

"An apparition has appeared on the wall of the church," Tia Amalia said.

"The face of Christ," Tia Andrea said, and both bowed their heads and made the sign of the cross.

That is what the people of the mountain valleys were saying, that at sunset the dying light and the cracks in the mud painted the face of Christ on the adobe wall of the church. A woman on the way to rosary had seen the image, and she ran to tell her comadre. Together they saw it, and their story spread like fire up and down the mountains. The following afternoon all the people of the village came and gathered in the light of dusk to see the face of Christ appear on the wall. Many claimed they saw the face; some said a man crippled by arthritis was cured and could walk when he saw the image.

You Sure Can't Tell from the Encyclopedia

FROM SHORT STORY "THE COMPLETE HISTORY OF NEW MEXICO," 1989
Kevin McIlroy

The President in those days, which was the 1845s, was James K. Polk and he wanted a war on Mexico so he declared one. Daniel said, "It shall not be easy."

"No?"

The way it turned out, it wasn't one bit. We cut across the highway and belly-crawled a corner of a chile field. You don't feel chile juice on you all at once because you just don't. But then. Oh, man.

Mrs. Orofolo's place was one big room and an indoor john, and a tree bigger than either one. She had a garden growing and it was neat and weeded and muddy and rotty too like a facefull of noserun. Daniel said muddy shoes would make his dad mad.

"It ain't going to make my dad grin," I said real quiet.

"You don't know."

I didn't. Sometimes you couldn't take the time to sit and think Daniel over. Sometimes he was 15,000 years old. And I had a lot of questions I wished I asked. How come buffalos which there aren't many left except in zoos always got a look on their face like you just called on them in school? Did President Polk believe that stuff about the Seven Cities of Cibola? Did he just want a dead beaver hat like everybody else? What got into the Pueblos when they drew wings on snakes all over their jars? What was the whatever-it-was that Bus knew that Daniel told him that I didn't know? What about those Franciscan guys? How come they acted like they didn't know nothing about slavery and massacres and all? Why didn't somebody around 1706 invent the camera and take pictures? How come no Conquistador Women came over? Did they ever come over? Because you sure can't tell from the Encyclopedia.

Portrait of Don Gasper De Villagrá, artist unknown, 1610

Spanish explorer who wrote an early history of what is now New Mexico.

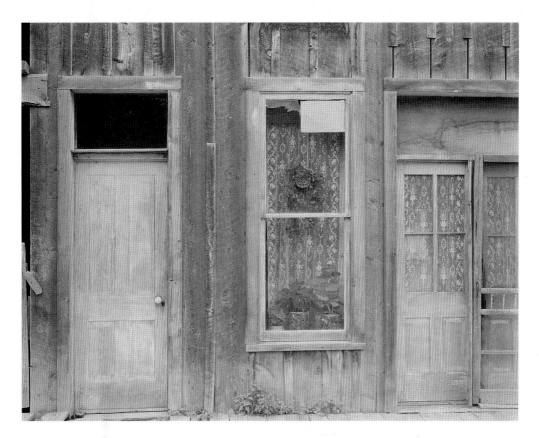

Red River, New Mexico, photograph by Paul Strand, 1931

Empty House
Rosario Castellanos

TRANSLATED BY MAUREEN AHERN

I remember a house I left behind.
It's empty now.
Curtains blowing in the wind,
boards clapping stubbornly
against old walls.
In the garden where grass begins
to spill its borders,
through the rooms of covered furniture,
among the empty mirrors,
loneliness
glides and wanders
on silent velvet feet.

A girl grew up here,
her slim sad cypress body sprouted
where her footsteps have left their imprint
along the hollow silent corridor.

(Two braids stretching down her back
like twin guardian angels.
Her hands only knew how
to close windows.)

Grey adolescence, shadowy vocation,
a destiny of death:
the stairways sleep. A house
that could never hold you collapses.

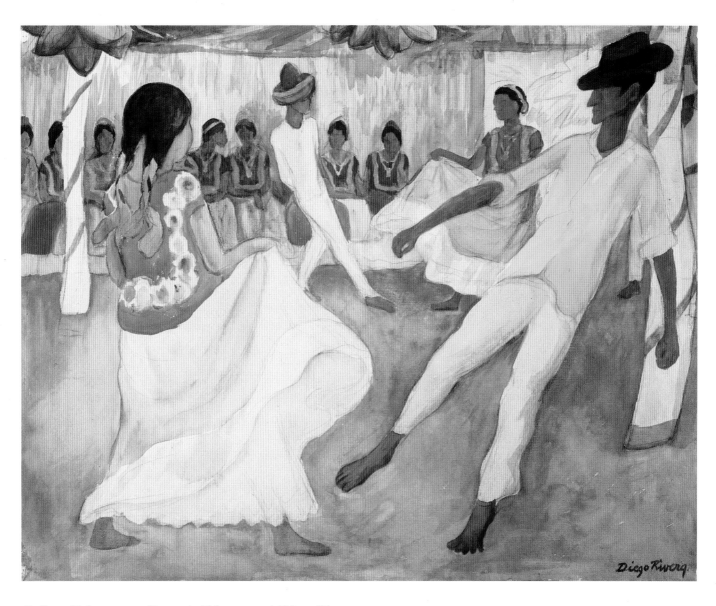

Baile en Tehuantepec (Dance in Tehuantepec), Diego Rivera, 1935

Bailes Were Held in Every Town or Village

FROM ESSAY "TRADITIONAL FOLK DANCES OF NEW MEXICO"
Anita Gonzáles Thomas

Bailes [dances] were held in every town or village, in *salas* [living rooms] with whitewashed walls lit by tallow candles. Before 1850 most of the salas had hard-packed clay floors with wheat straw scattered over them to keep the dust down.

On a table at one end of the sala were chairs for the *músicos* [musicians] who played violin and guitar. Often, before the dance, the músicos would ride in a

wagon through the town and adjoining villages to express a *convite,* an invitation for everyone to come to the dance.

The large homes of the ricos always had a sala for the bailes celebrating *prendorios* [an archaic word for engagements], *bodas* [weddings], *cumpleaños* [birthdays], and other events to which family and friends were invited. Sometimes in order to be assured of having another dance soon, some couple was *prendado* or *amarrado,* actually tied with a handkerchief, and not untied until someone would promise to redeem them by giving a *baile de desempeño* [dance of redemption].

Home
Gustavo Pérez-Firmat

Give a guy a break.
Take him back, let him step
on soil that's his or feels his,
let him have a tongue,
a story, a geography.
Let him not trip back and forth between
bilingualisms,
hyphens,
explanations.
As it is he's a walking-talking bicameral page.
Two hemispheres and neither one likes the other.
Ambidextrous.
Omnipossibilist.
Multivocal.
Let him stop having to translate himself
to himself
endlessly.
Give the guy a break:
crease him, slip him into an envelope,
address it, and let him go.
Home.

Footprint in the Sand,
photograph by Tom Dillehay, 1983

Here is one of the earliest traces of human life in the Americas. Nearly 13,000 years old, it was found under thick vegetation in Monte Verde, Chile, by Professor Dillehay, an anthropologist.

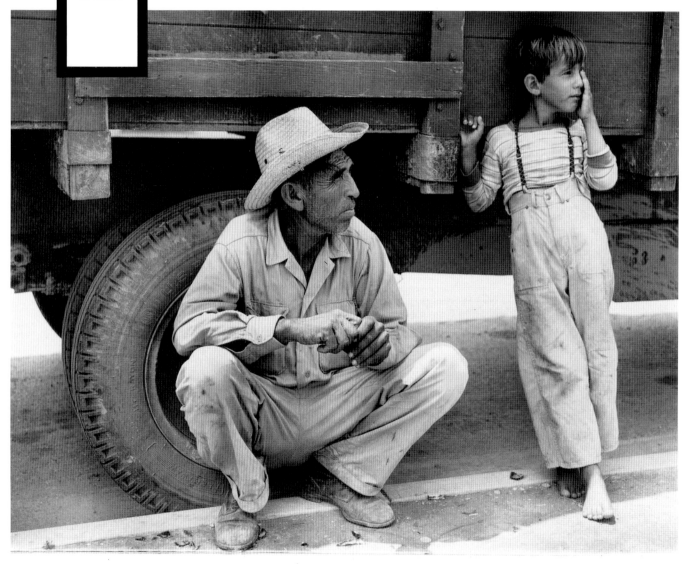

Migratory Birds

Odilia Galván Rodríguez

To Antonia

you were born
to gypsies
though you didn't
want to be
every spring
when orange blossom's
perfume
filled the air
your world was packed
into a few bundles
then your
family was off
living in tents
trailers
dirt floor shacks

you were born
to nomads
though you didn't
want to be
longed to live
with the
settled and the straight
work in the
five-and-dime
go to school
play tennis
and every time
you found a friend

it was time to go
another town
another round
in a world
that made you
dizzy

you were born
to migrants
though you didn't
want to be
from Texas to Illinois
living a blur
out a car window
roads endless
as fields of crops
to be picked by the piece
never making enough
to eat
let alone for the trip back
home
pleading for the
traveling to stop
words in the wind
wooshing by ears
of the gypsy king

you were born
to wanderers
though you didn't
want to be
when you got
the chance
you planted
yourself

deep
in concrete
and steel
to make sure
you or your
offspring
wouldn't
branch out
too far
from home
you were
settled
for
ever

I was born
to a life of never change
though I didn't
want to be
same familiar streets
same people
same stories
year after year
until one sweltering
Chicago summer night
the moon full
color of sun
reflecting off
fields of green
and the sweet scent
of lilacs from
our backyard
helped me sprout wings
so I could fly away.

Farm Laborer and His Grandchild Near San Angelo, Texas, photograph by Russell Lee, 1949

One of many migrant families who have followed the harvest north from the Mexican border to Wyoming.

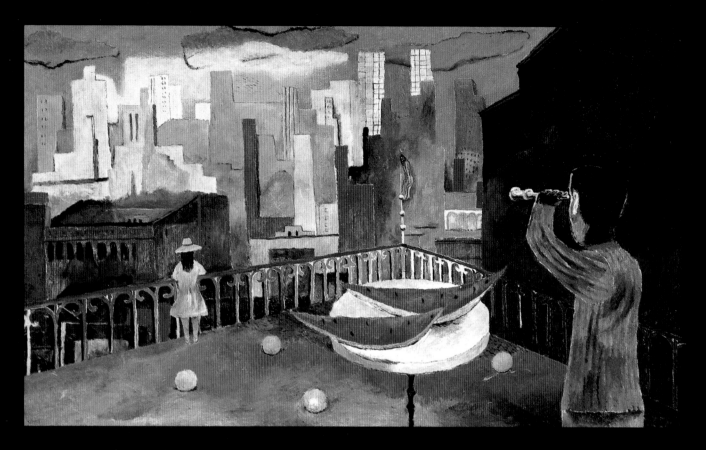

New York from the Roof Garden, Rufino Tamayo, 1937

We Live by What We See at Night
Martin Espada

for my father

When the mountains of Puerto Rico
flickered in your sleep
with a moist green light,
when you saw green bamboo hillsides
before waking to East Harlem rooftops
or Texas barracks,
when you crossed the bridge
built by your grandfather
over a river glimpsed
only in interrupted dreaming,
your craving for that island birthplace
burrowed, deep
as thirty years' exile,
constant as your pulse.

Why Do I Write about Puerto Ricans?
Nicholasa Mohr
FROM AN INTERVIEW CONDUCTED BY RONI NATOV
AND GERALDINE DELUCA

I just write about what I know and care very deeply
about. I think that the more specific you are in your
work, the more universal you become. If I can appre-
ciate a story by Sholem Aleichem about someone in an
eastern European village, someone else can certainly
appreciate a story about a Puerto Rican child. So I just
write about the human drama, the human struggle of
an ongoing life to the best of my knowledge. I write
about Puerto Ricans because that's what I am.

The Habit of Movement

Judith Ortiz Cofer

Nurtured in the lethargy of the tropics,
the nomadic life did not suit us at first.
We felt like red balloons set adrift
over the wide sky of this new land.
Little by little we lost our will to connect,
and stopped collecting anything heavier
to carry than a wish.
We took what we could from books borrowed
from Greek temples, or holes in the city
walls, returning them hardly handled.

We carried the idea of home on our backs from
house to house, never staying long enough to
learn the secret ways of wood and stone, and
always the blank stare of undraped windows behind
us like the eyes of the unmourned dead.
In time we grew rich in dispossession and
fat with experience.
As we approached but did not touch others,
our habits of movement kept us safe like
a train in motion, nothing could touch us.

Mural at Longfellow Elementary
School, Albuquerque, New Mexico
(detail), Francis Rivera, 1983

Octavio Medellin in His Studio, photograph, about 1938

This sculptor, who moved to South Texas from Mexico, was able like the poet to find beauty in a rock.

Art of the Americas, Pre-Columbian and Contemporary, catalogue cover designed by Alexandre Hogue for the art show at the Greater Texas and Pan-American Exposition, 1937

Some people do not realize that art from Latin America has been welcome in the United States for many years.

The Issue of Identity in Latin America

EXCERPT FROM SPEECH IN 1991, "DOES ART FROM LATIN AMERICA NEED A PASSPORT?"
Luis Felipe Noe

The issue of identity in Latin America is like the sword of Damocles, suspended over the heads of the artists in this part of the world. The sword will fall on the heads of those who don't want to deal with it. It is a logical concern, a reaction against cultural dependence on Europe and now, on the U.S. But, is our problem being correctly formulated in this way? I can understand that third parties—that is, people from the above-mentioned countries—will state the problem in this way because of their ignorance; they do it as a policeman who demands identification papers, or the bureaucrat who asks for your birth certificate. This attitude is the same as asking if Latin American art exists, and if it does, how does one define it?

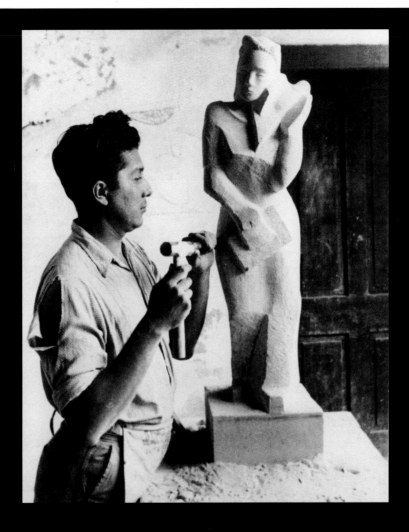

South Texas Summer Rain

Rebecca Gonzales

Dust cools easily
with the lightest summer rain.
Not rocks.
In the midst of dry brush,
they hold the sun like a match,
a threat to the water
that would wear them out.

Dust becomes clay,
cups rain like an innocent offering.
Not rocks.

They round their backs to the rain,
channel it down the street where children play,
feeling the rocks they walk on,
sharp as ever under the water,
streaming away.

If rocks hold water at all,
it's only long enough
for a cactus to grow gaudy flowers,
hoard a cheap drink,
flash it like a sin
worth the pain.

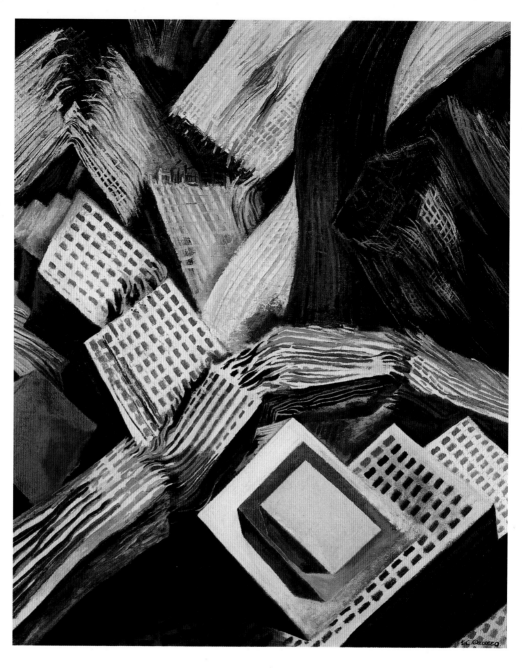

Los Muertos (Skyscrapers), José Clemente Orozco, 1931

Buffalo Levitates
FROM "BUFFALO"
Jorge Guitart

Buffalo levitates
and is the city in the sky.
The short skyscrapers
are upside down in a puddle.
The puddle freezes.
Buffalo lands upright.

Constructive Composition,
Joaquín Torres-García,
1931

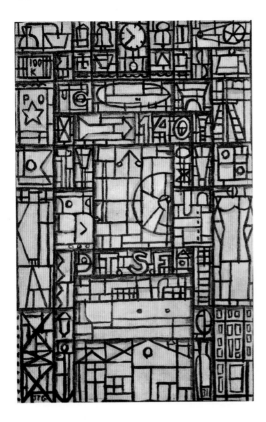

Crossings
Judith Ortiz Cofer

Step on a crack.
In a city of concrete it is impossible
to avoid disaster indefinitely.
You spend your life peering
downward, looking for flaws,
but each day more and more fissures
crisscross your path, and like the lines
on your palms, they mean something
you cannot decipher.
Finally, you must choose between
standing still in the one solid spot you
have found, or you keep moving
and take the risk:
Break your mother's back.

A Wind Will Come from the South
Circe Maia

TRANSLATED BY PATSY BOYER AND MARY CROW

A wind will come from the south with unleashed rain
to beat on closed doors and on the windows
to beat on faces with bitter expressions.

Happy noisy waves will come
climbing paths and silent streets
through the port district.

Let the hardened city wash its face
its stones and dusty wood, worn out
its heart sombre.

Let there be surprise at least in the opaque
taciturn glances.
And let many people be frightened, and the children laugh
and the greenness of the water's light wake us
bathe us, follow us.

Let it make us run and embrace each other
and let the doors of all the houses open
and the people come out
down the stairs, from the balconies,
calling to each other…

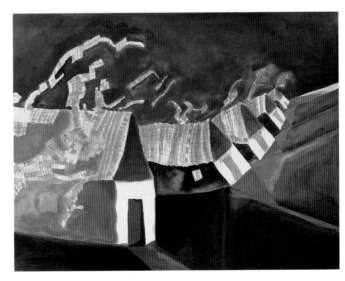

Flying Tiles, Francisco Toledo, about 1965

She Looked Like Her Adobe House

FROM NOVEL *Nambe — Year One*
Orlando Romero

 She looked like her adobe house. It was so weathered by time that most of the mud plaster was cracking and the wood of the windows had turned a soft, wild nappy gray.

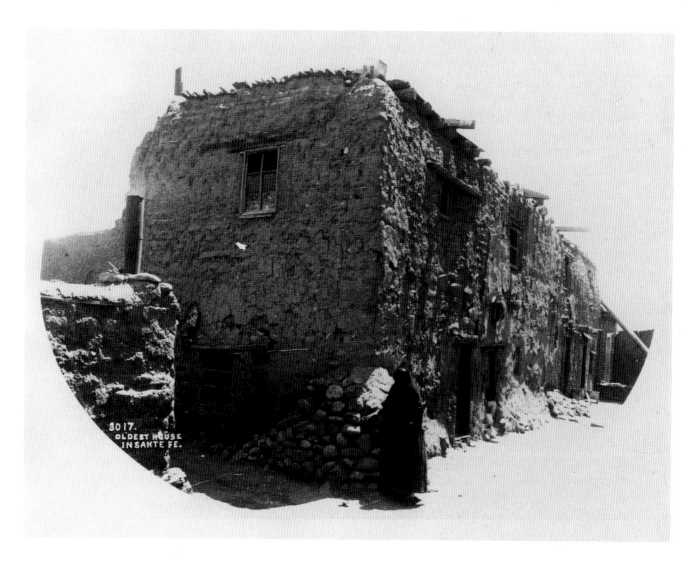

Oldest House in Sante Fe, New Mexico, photograph by William H. Jackson, about 1881

Already "old" more than a century ago, this ancient house on De Vargas Street may have been "new" in the year 1250!

The Baseball Zone

FROM REMARKS AT A CONFERENCE ON
LATIN-AMERICAN ART, LITERATURE, AND
IDENTITY, 1991
Gerardo Mosquera

The North American presence and influence in Latin America is due above all to the working of the great cultural networks of movies, television, publications and museums, all of which exercise an extraordinarily strong pull on the culture of my continent. I think that it is always proper to remember that this cultural pressure is obviously based on a system of economic, political and social neo-colonialism exercised over Latin America by its powerful neighbor to the north.

An obvious point of this influence is in sports. Rather than referring to "Latin America," I like to call this region the "Baseball Zone." I mean a zone that includes Central America, the Antilles, and the northern part of South America. And since we are talking about the Border, I've had the opportunity of being present at the frontier of that baseball zone. It was in the Venezuelan Andes, in one of those semi-arid areas, more than 3,000 meters high, where I watched a baseball game, complete with all the rules and regulations. It was quite a shock to me. The players were, well, very Andean-looking individuals, and it turned out to be somewhat shocking to me to see them pitching and calling strikes way up there.

Roberto Clemente at Bat, photograph by Neil Leifer, 1960s

The writer thinks baseball is a "North American" invention that people in other places—even the Andes Mountains—have to copy.

Ancient Stone Figures in the Andes, photograph by Arthur Rickerby, 1960s

Maybe people were playing baseball in the Andes long before "North America" was invented!

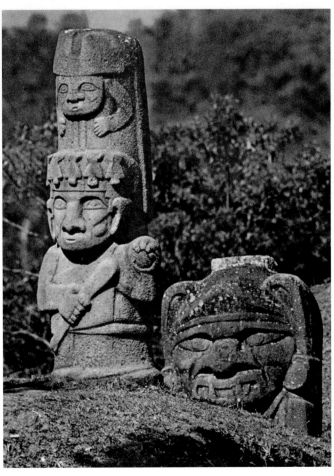

The Jungle, Wifredo Lam, 1943

The painter, like the poet, has seen an unfamiliar world of strange and ugly creatures.

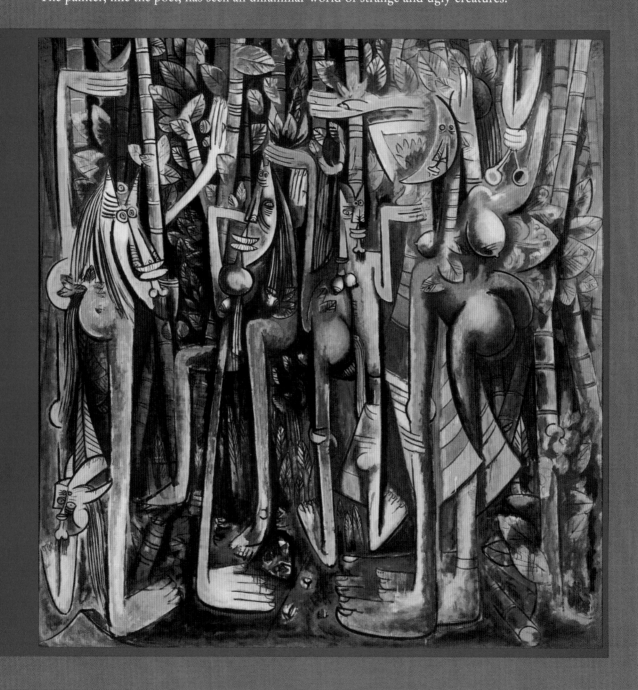

Give Me Back My World

Rita Geada

TRANSLATED BY DONALD D. WALSH

Give me back my world
with its angels of light and darkness.
But not these corpses.
These claws.
These statues lined up for sale.
Always the same.
Already out of date!
The clock measures them and controls them.
They bring nothing of the rainbow fled between the fingers.
Confront me with other looks.
With other hands.
With other gestures.
With other words.
Now that everything is slowly turning black,
black,
black.
Where are the colors, their shades?
Give me back what is mine even though it's only
pieces of its threadbare light.

When I Came to the End of the Street

The Thief, Julio Larraz, 1985

FROM "WORDS OF THE PRODIGAL SON"
Cintio Vitier

TRANSLATED BY DARWIN J. FLAKOLL AND CLARIBEL ALEGRÍA

When I came to the end
of the street nothing had changed.
Yes, nothing had changed. The change
was an emptiness shining in the windows and clouds.
It was the same place that had always been another
—twilight knows how to change an emptiness—
and I walked by the same backdrop,
perhaps watched by an enthusiastic public
who in moments of forgetting walk the street.
Perhaps it would have been better not to come
and see that nothing had changed,
that here were the familiar places, as strange
as ever, that always had been that way,
although something was missing, which I could not remember,
which always had been missing.

I grew weak then in a dreadful way,
I lost substance or someone
I could not name stole it from me;
I was like a child that suddenly
has begun to forget all notion of time
and no longer sustains the idea of his being, and hears
a vague clangor spilling coldness
in the center of his heart.
It was an epoch of changes and twilights.
I came undone then, but the air
I remembered was missing; like a dream
of unsuspected whiteness it began to awaken me;
since everything was so gentle,
so full of nothingness, so much the same and so different,
and that which was lacking in everything was so pure,
I knew my home, or whatever the place
that impelled me, could not be very far.

Chula, Manuel Neri, about 1958–60

Chula is slang for "girl" or "young woman."

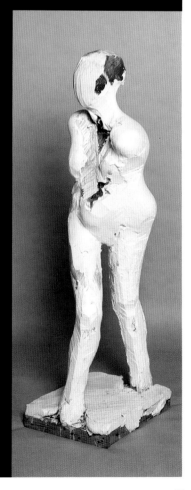

Color
Roberto Durán

Excuse me white
off-white pale america
in my search and journeys
of my brown life
on blue green planet earth

West Side Story, Playbill cover, 1957

This famous Broadway musical introduced some new notes to the sounds of America singing.

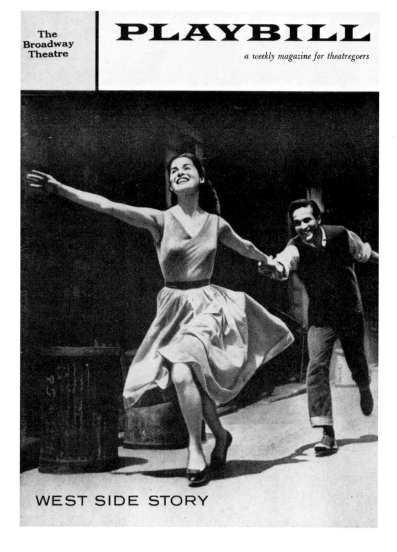

PLAYBILL

The Broadway Theatre

a weekly magazine for theatregoers

WEST SIDE STORY

I Hear America Singing

FROM *Leaves of Grass*
Walt Whitman

I hear America singing, the varied carols I hear,
Those of mechanics, each one singing his as it should be blithe and strong,
The carpenter singing his as he measures his plank or beam,
The mason singing his as he makes ready for work, or leaves off work,
The boatman singing what belongs to him in his boat, the deckhand singing on
 the steamboat deck,
The shoemaker singing as he sits on his bench, the hatter singing as he stands,
The wood-cutter's song, the ploughboy's on his way in the morning, or at
 noon intermission or at sundown,
The delicious singing of the mother, or of the young wife at work, or of the
 girl sewing or washing,
Each singing what belongs to him or her and to none else.

The Boundaries of the Barrio

FROM NOVEL *Barrio Boy,* 1971
Ernesto Galarza

It was a block in one direction to the lumber yard and the grocery store; half a block in the other to the saloon and the Japanese motion picture theater. In between were the tent and awning shop, a Chinese restaurant, a secondhand store, and several houses like our own. We noted by the numbers on the posts at the corners that we lived between 4th and 5th streets on L. Once we could fix a course from these signs up and down and across town we explored further. On Sixth near K there was the Lyric Theater with a sign we easily translated into Lírico.... Navigating by these key points and following the rows of towering elms along L Street, one by one we found the post office on 7th and K; the cathedral, four blocks farther east; and the state capitol with its golden dome.... These were the boundaries of the lower part of town, for that was what everyone called the section of the city between Fifth Street and the river and from the railway yards to the Y-street levee. Nobody ever mentioned an upper part of town; at least, no one could see the difference because the whole city was built on level land. We were not lower topographically, but in other ways that distinguished between Them, the uppers, and Us, the lowers.

the story of a boy's acculturation

BARRIO BOY

BY ERNESTO GALARZA NDP 118

This Is a Bright *Mundo*

FROM PROLOGUE OF NOVEL *Down These Mean Streets,* 1967
Piri Thomas

This is a bright *mundo,* my streets, my *barrio de noche,*
With its thousands of lights, hundreds of millions of colors,
Mingling with noises, swinging street sounds of cars and curses,
Sounds of joys and sobs that make music....

Cover illustration of Ernesto Galarza's novel *Barrio Boy,* 1971

The *barrio* is a well-known neighborhood, but its edges may be "barriers" to prevent us from meeting new people, new experiences, new ideas.

America Is Hard to See

Robert Frost

Columbus may have worked the wind
A new and better way to Ind
And also proved the world a ball,
But how about the wherewithal?
Not just for scientific news
Had the Queen backed him to a cruise.

Remember he had made the test
Finding the East by sailing West.
But had he found it? Here he was
Without one trinket from Ormuz
To save the Queen from family censure
For her investment in his venture.

There had been something strangely wrong
With every coast he tried along.
He could imagine nothing barrener.
The trouble was with him the mariner.
He wasn't off a mere degree;
His reckoning was off a sea.

Manuscript Map of the World, Juan Vespucci, Seville, 1526

The Americas got their name from the uncle of the maker of this map! Amerigo Vespucci (1451?–1512) was born in Italy, traveled a lot, and served as navigator for several Spanish and Portuguese voyages of discovery.

68

And to intensify the drama
Another mariner, da Gama,
Came just then sailing into port
From the same general resort,
And with the gold in hand to show for
His claim it was another Ophir.

Had but Columbus known enough
He might have boldly made the bluff
That better than da Gama's gold
He had been given to behold
The race's future trial place,
A fresh start for the human race.

He might have fooled Valladolid.
I was deceived by what he did.
If I had had my chance when young
I should have had Columbus sung
As a god who had given us
A more than Moses' exodus.

But all he did was spread the room
Of our enacting out the doom
Of being in each other's way,
And so put off the weary day
When we would have to put our mind
On how to crowd but still be kind.

For these none-too-apparent gains
He got no more than dungeon chains
And such small posthumous renown
(A country named for him, a town,
A holiday) as, where he is,
He may not recognize for his.

They say his flagship's unlaid ghost
Still probes and dents our rocky coast
With animus approaching hate,
And for not turning out a strait,
He has cursed every river mouth
From fifty North to fifty South.

Someday our navy, I predict,
Will take in tow this derelict
And lock him through Culebra Cut,
His eyes as good (or bad) as shut
To all the modern works of man
And all we call American.

America is hard to see.
Less partial witnesses than he
In book on book have testified
They could not see it from outside—
Or inside either for that matter.
We know the literary chatter.

Columbus, as I say, will miss
All he owes to the artifice
Of tractor-plow and motor-drill.
To naught but his own force of will,
Or at most some Andean quake,
Will he ascribe this lucky break.

High purpose makes the hero rude;
He will not stop for gratitude.
But let him show his haughty stern
To what was never his concern
Except as it denied him way
To fortune-hunting in Cathay.

He will be starting pretty late.
He'll find that Asiatic state
Is about tired of being looted
While having its beliefs disputed.
His can be no such easy raid
As Cortez on the Aztecs made.

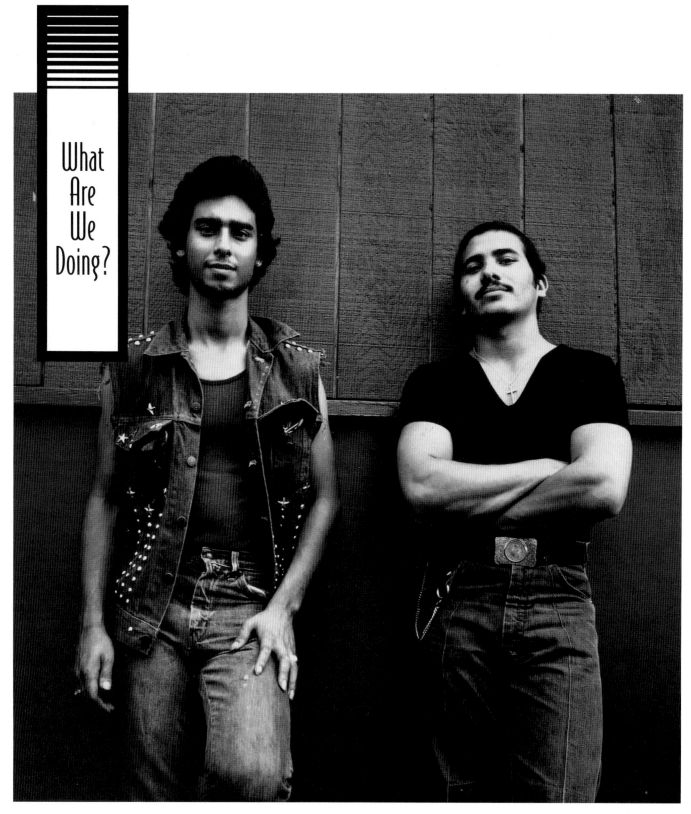

What
Are
We
Doing?

You Don't Fool Around with the Devil
FROM NOVEL . . . *And the Earth Did Not Devour Him*
Tomás Rivera

"I tell you, compadre, you don't fool around with the devil. There are many who have summoned him and have regretted it afterwards. Most of them go insane. Sometimes they get together in groups to summon him, so they won't be afraid. But he doesn't appear before them until later, when each of them is alone, and he appears in different shapes. No, nobody should fool with the devil. If you do, as they say, you give up your soul. Some die of fright, others don't. They just start looking real somber and then they don't even talk anymore. It's like their spirits have left their bodies."

Sons of the Devil, photograph by Luis Medina, 1980–84
Members of a Chicago gang.

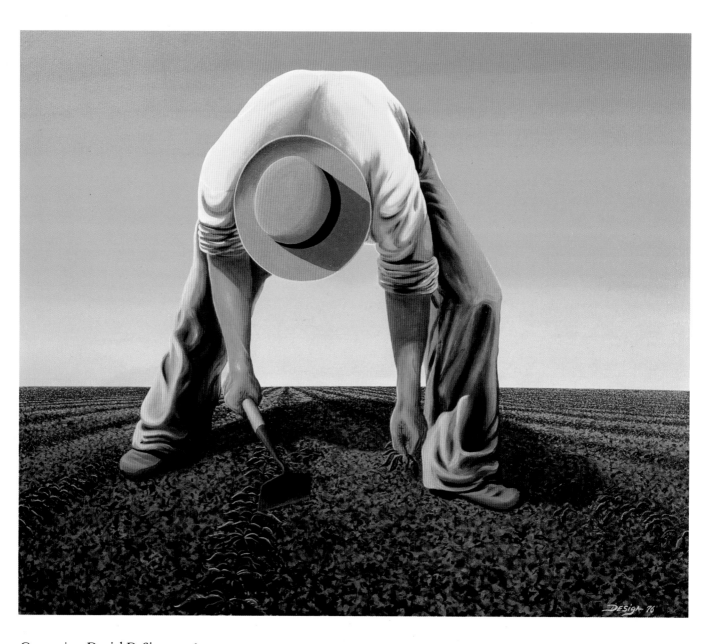

Campesino, Daniel DeSiga, 1976

The endless field symbolizes the work of the farm laborer, which comes to an end only with the harvest.

Little Tortillas

MEXICAN-AMERICAN FOLK SONG

Little tortillas, little tortillas
little tortillas for Pa-pa,
little tortillas for Ma-ma;
little tortillas made of bran
when Pa-pa is a worried man;
little tortillas brown and snappy
for Ma-ma when she is happy.

Tortilla molds, maker unknown, Mexico, 1930s

The Best Time of the Year

FROM SHORT STORY "THE HARVEST"
Tomás Rivera

TRANSLATED BY JULIÁN OLIVARES

The end of September and the beginning of October. That was the best time of the year. First, because it was a sign that the work was coming to an end and that the return to Texas would start. Also, because there was something in the air that the folks created, an aura of peace and death. The earth also shared that feeling. The cold came more frequently, the frosts that killed by night, in the morning covered the earth in whiteness. It seemed that all was coming to an end. The folks felt that all was coming to rest. Everyone took to thinking more. And they talked more about the trip back to Texas, about the harvests, if it had gone well or bad for them, if they would return or not to the same place next year. Some began to take long walks around the grove. It seemed like in these last days of work there was a wake over the earth. It made you think.

On the Island I Have Seen

Judith Ortiz Cofer

Men cutting cane under a sun relentless
as an overseer with a quota,
measuring their days
with each swing of their machetes,
mixing their sweat with the sugar
destined to sweeten half a continent's coffee.

Old men playing dominoes in the plazas
cooled by the flutter of palms,
divining from the ivory pieces
that clack like their bones, the future
of the children who pass by on their way to school,
ducklings following the bobbing beak
of the starched nun who leads them in silence.

Women in black dresses keeping all the holy days,
asking the priest in dark confessionals
what to do about the anger in their sons' eyes.
Sometimes their prayers are answered
and the young men take their places
atop the stacked wedding cakes.
The ones who are lost to God and mothers
may take to the fields, the dry fields,
where a man learns the danger of words,
where even a curse can start a fire.

Little Mexico, William Lester, 1930

Mexican workers moved more easily to El Paso, Dallas, and other Southwestern cities during the prosperous early years of this century, but when the "boom" was over and jobs were scarce, the story changed.

Workers from South of the Border

FROM BOOK *Desert Immigrants: The Mexicans of El Paso, 1880–1920*
Mario T. García

Limited in industrial production, the Southwest was in special need of unskilled railroad hands, farmworkers, mine and smelter laborers, and a variety of other forms of menial labor. Lacking a local labor market and finding it difficult to recruit European and Asian immigrants owing to geographic distance and racial prejudices, entrepreneurs soon discovered a profitable and acceptable labor supply south of the border. Together, industrialization, regional economic specialization, and Mexican immigrant labor launched an economic boom in the Southwest and in the process created new and enlarged Mexican communities within the United States. Mexican immigration, as such, is rooted in late nineteenth-century American economic developments associated with the growth and expansion of American capitalism.

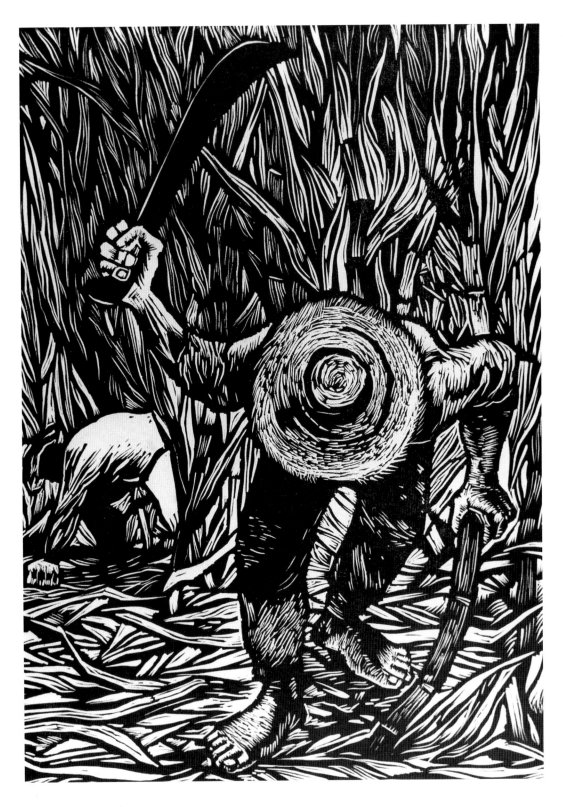

Cortador de Caña (Cane Cutter), Rafael Tufiño, 1951–52

The Young Sor Juana

Pat Mora

I

I'm three and cannot play away my days to suit
my sweet *mamá,* Sleep well, my dolls, for I must run
to school behind my sister's frowns. She knows my secret
wish to stretch, if only I were taller, if only I could
tell *Mamá* why I must go, my words irresistible as roses.

My sister hears my tiptoes, knows her shadow
has my face. I tiptoe on, for I must learn to unknit words
and letters, to knit them new with my own hand.
Like playful morning birds the big girls giggle, at me,
the little tagalong. I hear the grumble of my sister's frown.

I stretch to peek inside, to see the teacher's face,
How it must glow with knowledge. Like the sun
A woman so wise has never tasted cheese. She sees
my eyes and finally seats me near. My stubborn legs
and toes refuse to reach the floor.

At noon I chew my bread. Others eat soft cheese.
I've heard it dulls the wits. I shut my lips to it.
I must confess, when tired, I slowly smell the milky moons,
like *Mamá* savors the aroma of warm roses.
I linger, imagine my teeth sinking into the warm softness.

II

I'm seven and beg to leave my sweet *mamá,* to hide
myself inside boys' pants and shirt, to tuck
my long, dark hair inside a cap so I can stride
into large cities, into their classrooms, into ideas crackling
and breathing lightning.

Instead of striding I must hide from frowns,
from dark clouds in the eyes of my *mamá.* I hide
in my grandfather's books, sink into the yellowed
pages, richer than cheese. Finally *Mamá* releases me
to her sister. I journey to the city. If only I were taller.

Self-Portrait with Cropped Hair, Frida Kahlo, 1940

A classic story: Sor Juana was a wealthy young woman who gave up almost everything, including her long and lovely hair, to help others.

III
I'm sixteen and spinning in the glare of Latin
grammar. I cannot look away. Beware, slow wits,
I keep my scissors close, their cold, hard
lips ready to sink into this dark, soft hair,
punish my empty head, unless it learns on time.

I'll set the pace and if I fail, I'll hack and slash
again until I learn. I'll pull and cut, this foolish lushness.
Again I'll feel my hair rain softly on my clothes, gather
in a gleaming puddle at my feet.
My hands are strong, and from within I rule.

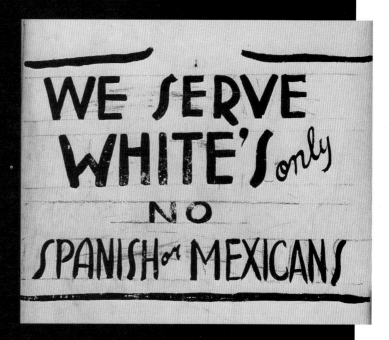

We Serve White's Only, photograph by Russell Lee, 1949

Sign found on a restaurant in San Antonio, Texas,
at a time when discrimination was strong.

Hot Chile

Leroy V. Quintana

Don José says Chicanos have suffered so much;
That we're so used to it
we like to suffer
even when we eat.

If You Ask for Chili at the Coyote Cafe, You Are Speaking Aztec!

Here are some examples of Nahuatl (Aztec) words "borrowed"
by the English language:

NAHUATL	ENGLISH
Ahuacatl	Avocado
Cacahuatl	Cacao, cocoa
Chocólatl	Chocolate
Coyotl	Coyote
Chictli	Chicle
Chilli	Chili
Mizquitl	Mesquite
Ocelotl	Ocelot
Peyotl	Peyote
Tamalli	Tamale
Tequilan	Tequila
Tomatl	Tomato

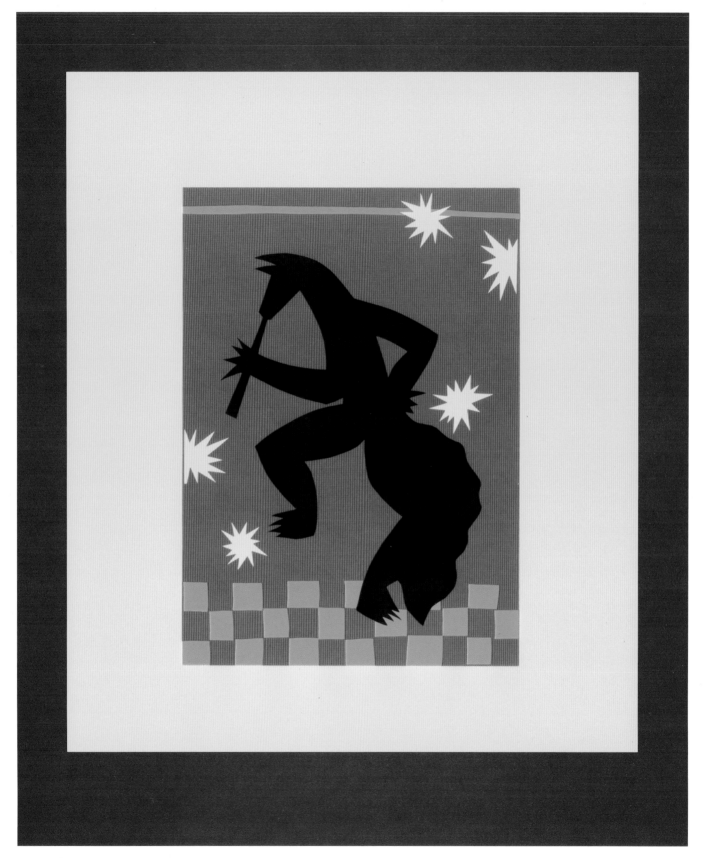

Recipe for Red Chile Sauce from the Coyote Cafe, Santa Fe, New Mexico

Mark Charles Miller

This is the most famous of all the New Mexican sauces. In fact, just as a great batting or golf swing makes the player, so the quality of the red chile sauce defines the quality of the cooking. To a great extent, the success of the sauce depends on the freshness of the chiles, which should be used in dried or powdered form (I like to use whole dried New Mexico red chiles). There are many versions of this sauce—this one is round, smooth, and deep. It has no sharp edges, and provides the setting and support for dozens of dishes, both simple and complex. It particularly complements tamales, enchiladas, red meats, and grilled food.

Yield: 4 cups

$1/2$ pound (about 25) whole dried New Mexico red chiles or red ancho chiles (or $1/2$ pound dried New Mexico red chile powder)
2 quarts water
1 pound Roma tomatoes
$1/2$ cup chopped white onion
1 tablespoon olive oil
5 large cloves garlic, roasted, peeled, and finely chopped
1 teaspoon roasted ground cumin
$1 1/2$ teaspoons roasted ground Mexican oregano
1 teaspoon salt
2 tablespoons peanut oil (or lard)

Remove stems and seeds from chiles. With a comal or black iron skillet, or in an oven at 250°, dry roast chiles for 3 to 4 minutes. Shake once or twice and do not allow to blacken. Add to the water in a covered pan and simmer very low for 20 minutes to rehydrate. Allow to cool. Blacken tomatoes in a skillet or under a broiler (about 5 minutes). Sauté onion in the oil over low heat until browned.

Drain chiles, reserving liquid, and put chiles in a blender. Add blackened tomatoes, onion, garlic, cumin, oregano, and salt. Add 1 cup liquid. (Taste the chile water first. If it is not bitter, use chile water, otherwise add plain water or chicken stock.) Purée to a fine paste, adding more chile water, water, or chicken stock if necessary.

Add oil or lard to a high-sided pan, and heat until almost smoking. Refry sauce at a sizzle for 3 to 5 minutes, stirring continuously. Do not allow sauce to get too thick; add water if necessary.

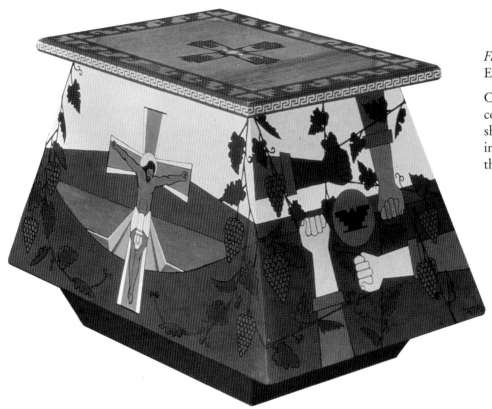

This Is the Beginning

FROM ESSAY "THE PLAN OF DELANO"
César Chávez and others

This is the beginning of a social movement in fact and not in pronouncements. We seek our basic, God-given rights as human beings. Because we have suffered—and are not afraid to suffer—in order to survive, we are ready to give up everything, even our lives, in our fight for social justice. We shall do it without violence because that is our destiny. To the ranchers, and to all those who oppose us, we say, in the words of Benito Juárez, "EL RESPECTO AL DERECHO AJENO ES LA PAZ."

Muralist

Odilia Galván Rodríguez

to Jane

sandia red
elote yellow
lupine purple
cobalt blue
colors
paint you
life in love
and struggle

before spring greens
there was a time
when even mauve orange
and green golden
Santa Cruz sunsets
couldn't make you smile

but now
amongst pavement blacks
gray-blue and steel
your power and strength
radiates clear
a prism

neon magenta
fuchsia, sky blue,
desert ochre,
cloud white, and the rest
shoot from your fingertips
transmuting blank-faced walls
 into sirens for peace

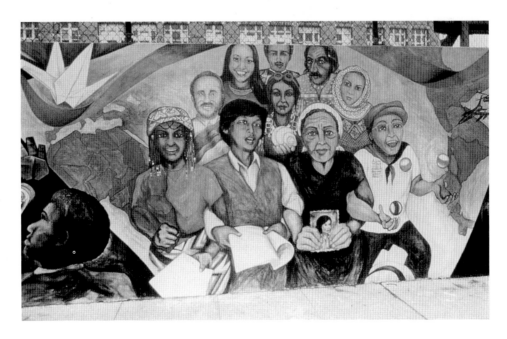

Educate to Liberate (detail), mural by Miranda Bergman, Jane Norling, Vicky Hamlin, Maria Ramos, and Arch Williams, 1988

The poet dedicated the poem to her friend Jane, one of the people who painted this outdoor picture at the corner of Hayes Street and Masonic Avenue, San Francisco. The "message" of the mural is important!

Where Are We Going?

Direction

Alonzo Lopez

I was directed by my grandfather
To the East,
 so I might have the power of the bear;
To the South,
 so I might have the courage of the eagle;
To the West,
 so I might have the wisdom of the owl;
To the North,
 so I might have the craftiness of the fox;
To the Earth,
 so I might receive her fruit;
To the Sky,
 so I might lead a life of innocence.

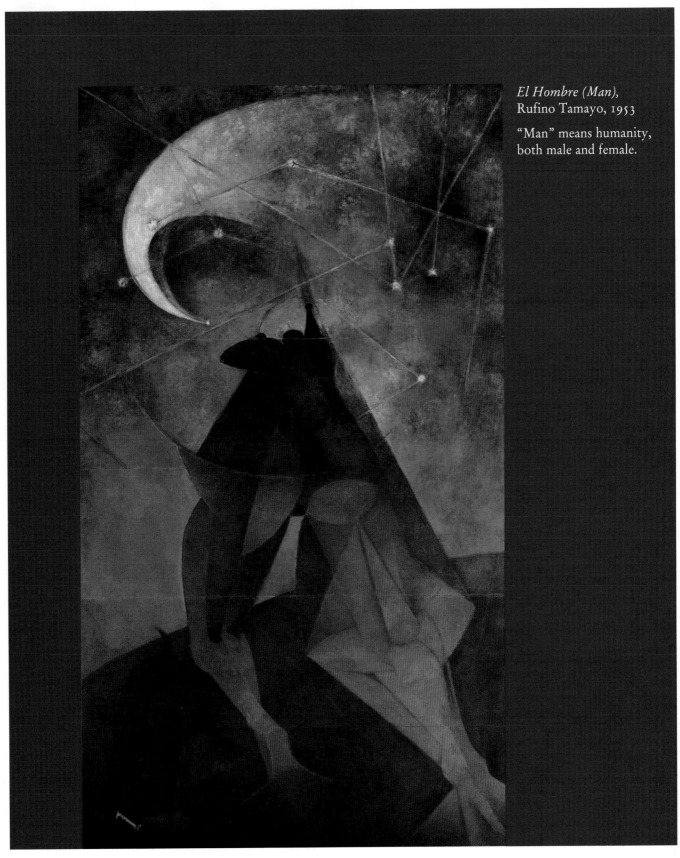

El Hombre (Man),
Rufino Tamayo, 1953

"Man" means humanity,
both male and female.

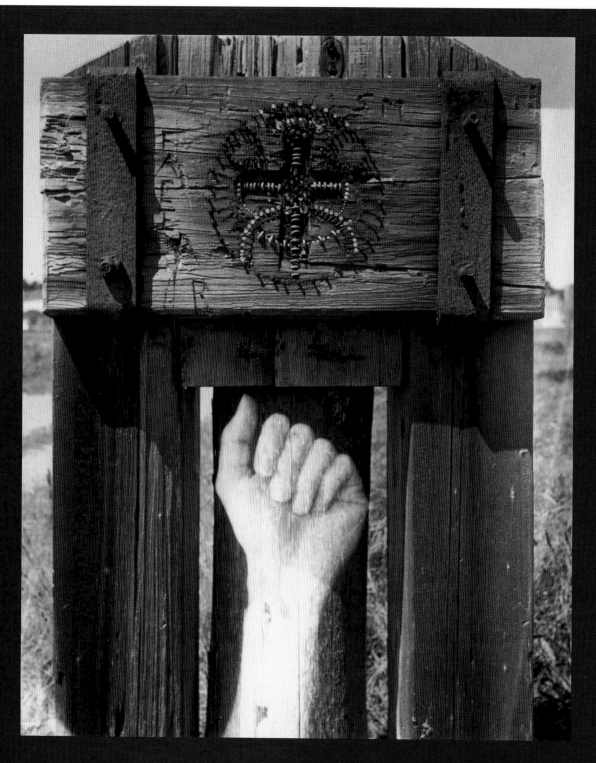

Mendocino Motif, photograph by Imogen Cunningham, 1959

Proverb

TRANSLATED BY CHARLES SULLIVAN

No puede negar la cruz de su parroquia.

You can't get away from the cross of your parish.

For Georgia O'Keeffe

Pat Mora

I want

to walk
with you
on my Texas desert,
to stand near
you straight
as a Spanish Dagger,
to see your fingers
pick a bone bouquet
touching life
where I touch death,
to hold a warm, white
pelvis up
to the glaring sun
and see
your red-blue world
to feel you touch
my eyes
as you touch canvas

to unfold
giant blooms.

Black Cross with Red Sky,
Georgia O'Keeffe, 1929

This dynamic painter
"adopted" the Southwest.

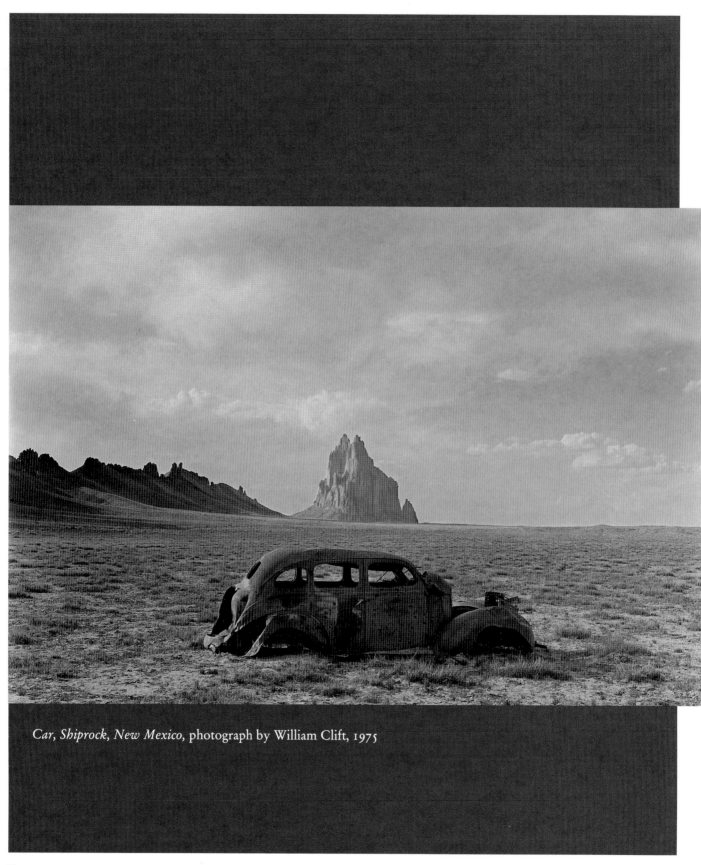

Car, Shiprock, New Mexico, photograph by William Clift, 1975

New Way, Old Way

Dave MartinNez

Beauty in the old way of life
The dwellings they decorated so lovingly;
A drum, a clear voice singing,
And the sound of laughter.

You must want to learn from your mother,
You must listen to old men
 not quite capable of becoming white men.
The white man is not our father.
While we last, we must not die of hunger.
We were a very Indian, strong, competent people,
But the grass had almost stopped its growing,
The horses of our pride were near their end.

Indian cowboys and foremen handled Indian herds.
A cowboy's life appealed to them until
 economics and tradition clashed.
No one Indian was equipped to engineer the water's flow
 onto a man's allotment.
Another was helpless to unlock the gate.
The union between a hydro-electric plant and
Respect for the wisdom of the long-haired chiefs
 had to blend to build new enterprises
By Indian labor.
Those mighty animals graze once more upon the hillside.
At the Fair appear again our ancient costumes.

A full-blood broadcasts through a microphone
 planned tribal action.
Hope stirs in the tribe,
Drums beat and dancers, old and young, step forward.

We shall learn all the devices of the white man.
We shall handle his tools for ourselves.
We shall master his machinery, his inventions,
 his skills, his medicine, his planning;
But we'll retain our beauty
And still be Indians!

Skeleton Vendor, Miguel Linares,
mid-1970s

The poet found life in the midst of
death, while the artist saw death in the
midst of life.

Encounter

Homero Aridjis

TRANSLATED BY WAYNE H. FINKE

We go to the pyramid
via the Street of the Dead

A girl descends
in the opposite direction
burned by the sun

goddess of flesh and bone
hardly covers other pyramids

she is lost in the ruins
backwards towards never

You and I go to the pyramid
via the Street of the Dead

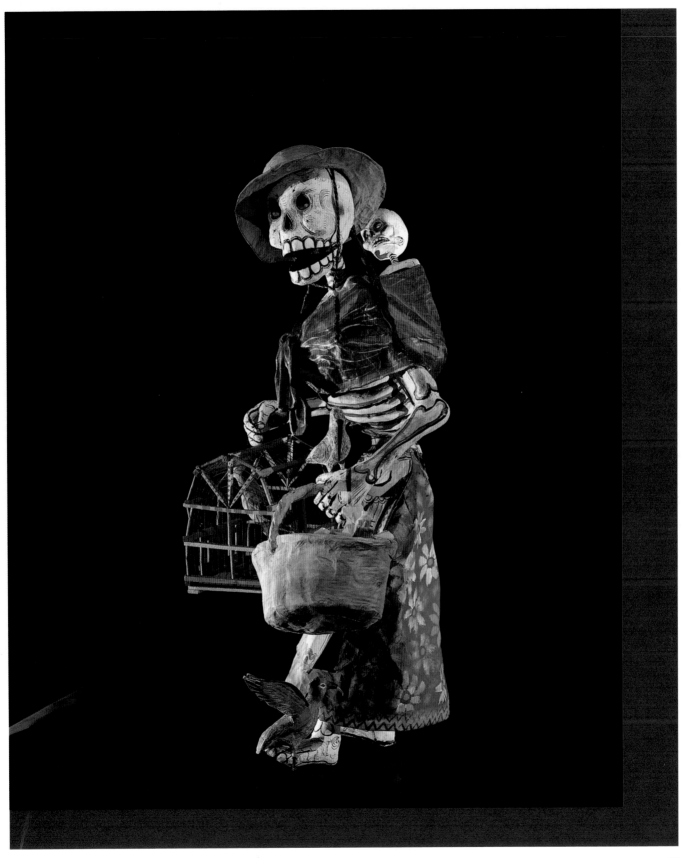

Lesson One: I Would Sing

Judith Ortiz Cofer

In Spanish, "cantaría" means I would sing,
Cantaría bajo la luna,
I would sing under the moon.
Cantaría cerca de tu tumba,
By your grave I would sing,
Cantaría de una vida perdida,
Of a wasted life I would sing,
If I may, if I could, I would sing.
In Spanish the conditional tense is the tense of dreamers,
of philosophers, fools, drunkards,
of widows, new mothers, small children,
of old people, cripples, saints, and poets.
It is the grammar of expectation and
the formula for hope: *cantaría, amaría, viviría.*
Please repeat after me.

Gloria Estefan, photograph by
Ken Nahoum, 1990

Let us sing, let us love,
let us live!

I Go Dreaming Roads in My Youth

Luis Omar Salinas

I'm not interested in the poverty
of ignorance and its songs,
to be generous to myself is my song;
I will give my shirt to no one
even though I talk too much and
give my words to the ungrateful
they will not find a home in my thoughts.

I put on my hat, stride forward,
act, dream, love; I take a drink
and let fame touch me, yet in the end
I'll place it to rest.

When I raise my arm to the populace
I raise it with sincerity
and pride in my monstrous vitality.
When the world clubs me
I shall fight back, if it loves me
I will love back, if it steps in my
shadow's fortune, I will give thanks
to God and those who surround me.

I have many stories, a haughty dramatist
weaving scenes of optimism, of alegria,
of romance. The world is too tired
and little concerned with pathos or
the consequences of tragedy.

What is important is the eloquence
of a river and a boy pushing a boat
into the water, a white dove gently
from the hands of his mother and
a clumsy serenade dreaming the afternoon.

Today, I like this world, and
if your life is worth nothing, don't sing,
don't come to my door with broken hearts
and complaints. Today, I go dreaming
roads in my youth.

The Boxer, Fernando Leal, 1924

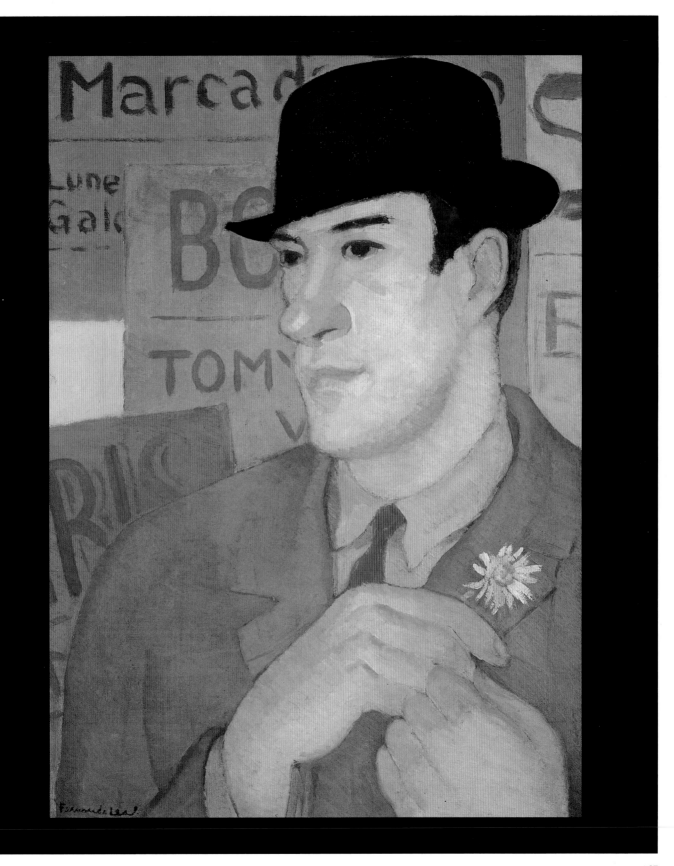

Graduation Day at the University of Puerto Rico at Río Piedras, photograph by Jack Delano, 1980

Advanced Course
Hjalmar Flax

Grammar lesson:
 You,
 first person singular,
 just as I.

Arithmetic lesson:
 One divided by one is one.
 One less one is zero.

History lesson:
 There is only one,
 but it will not be repeated
 for us.

Theology lesson:
 The infinite
 is a mirage
 that intensifies thirst.

Economics lesson:
 Offer more,
 ask for less.

Business lesson:
 Buy expensive.
 Sell very expensive.

Humanism lesson:
 Love today.
 Perhaps tomorrow you will love again.

Politics lesson:
 Who governs himself
 does not need borders.

Physics lesson:
 It is not just the impulse,
 also the moment counts.

John Florez, 1992

Our Secret Will Be Education
FROM SPEECH FOR THE PRESIDENT'S ADVISORY
COMMISSION ON EDUCATIONAL EXCELLENCE FOR
HISPANIC AMERICANS, 1992
John Florez

People who have made it in America did it using
three types of power: political, economic and educa-
tion. Our secret will be education.

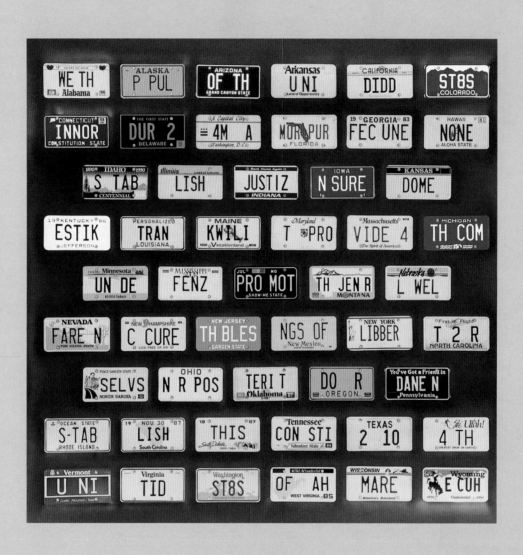

Preamble to the Constitution
of the United States of America

We the People of the United States, in Order to form
a more perfect Union, establish Justice, insure domestic
Tranquility, provide for the common defence, promote
the general Welfare, and secure the Blessings of Liberty
to ourselves and our Posterity, do ordain and establish
this Constitution for the United States of America.

Preamble, Mike Wilkens, 1987

The beginning of the U.S. Constitu-
tion is echoed in car license plates
from all fifty states plus the District
of Columbia.

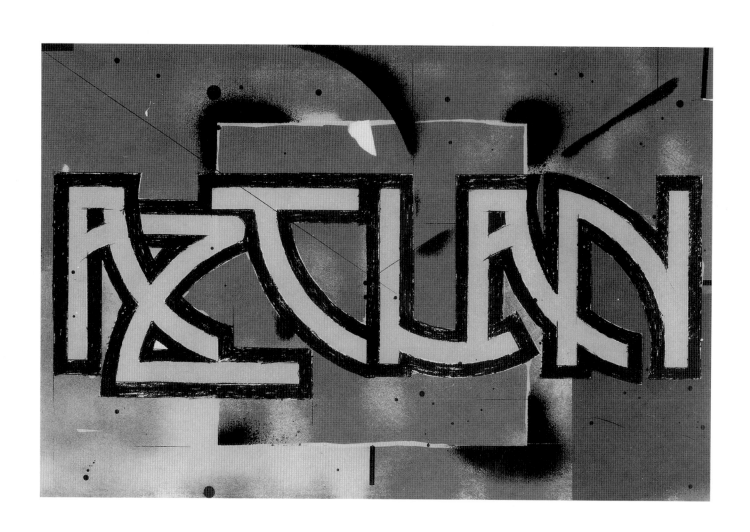

Aztlán, Richard Duardo,
1982

Perhaps "Aztlán" is the
best name for the kingdom
that all of us seek.

The Legend of Aztlán

FROM NOVEL *Heart of Aztlán*
Rudolfo A. Anaya

"There are many versions of the legend of Aztlán," Crispín began. "It is said that *the people* were the first human beings to walk on the shores of Aztlán. Where they came from is not recorded in the annals of the sun, and the stories have been so eroded by the waters of the stream of time that only a sentence or two remain to give an intimation of the entire story. Some say *the people* were a wandering tribe of the ancient world, spared during the drowning of the earth so that they might establish a civilization of peace in the new world. Other versions go further back and say that Aztlán was a floating continent that settled north of Mexico when the earth was young. There are seven springs on the sacred mountain, and the Indians call this the sipapu, the place of origin. The rays of the sun penetrated the dark waters of those sacred lakes and from this intercourse the people emerged. That is why there is so much power in that place; it is the source.

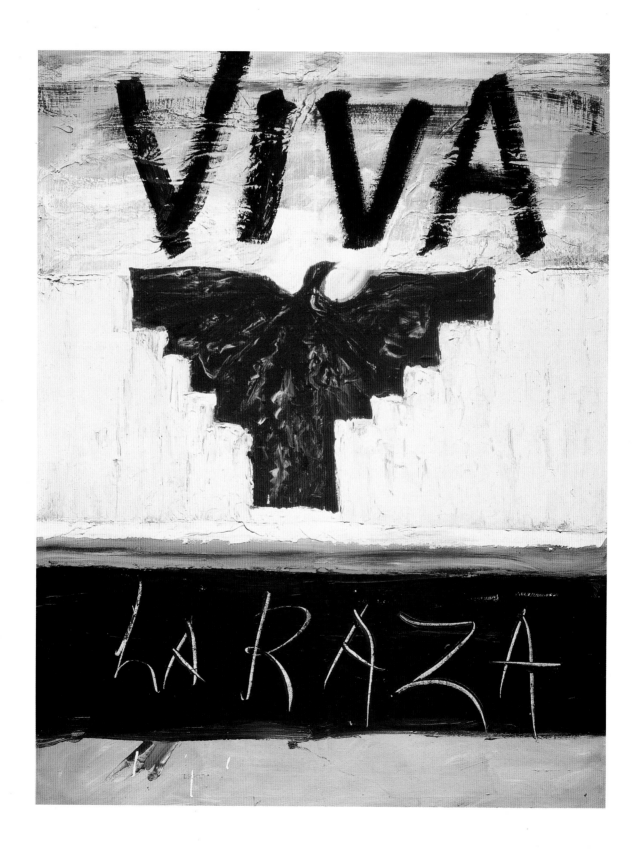

La Raza!
Rodolfo "Corky" Gonzales

 La Raza!
Mejicano!
 Español!
 Latino!
 Hispano!
 Chicano!
or whatever I call myself,
 I look the same
 I feel the same
 I cry
 and
 Sing the same

I am the masses of my people and
I refuse to be absorbed.
 I am Joaquín
The odds are great
but my spirit is strong

 My faith unbreakable
 My blood is pure
I am Aztec Prince and Christian Christ
 I SHALL ENDURE!
 I WILL ENDURE!

Viva La Raza (Long Live Humanity),
Salvador Roberto Torres, 1969

Perhaps "La Raza" is the best name
for all of us—the human race!

Biographical Notes

Following are brief biographical notes about the writers and artists, most of them Hispanic Americans, whose work appears in this book (or who are subjects of illustrations herein). Every effort has been made to achieve accuracy, but in some cases two or more sources gave different information about various matters.

Aguilar Family. Folk artists of Ocotlán de Morelos, Oaxaca, Mexico, who have captured the drama and color of village scenes in their large earthenware sculptures.

Anaya, Rudolfo A. (born 1937). Lives in New Mexico. Well-regarded writer, lecturer who has explored the two worlds of everyday struggle and spiritual search in his books, including *Bless Me, Ultima* (1972), *Heart of Aztlán* (1976), and *Aztlán: Essays on the Chicano Homeland* (1989).

Aridjis, Homero (born 1940). Mexican poet who has traveled extensively and has taught in several U.S. universities but stays close to his cultural roots in his books, such as *Exaltation of Light* (1981) and *1492: The Life & Times of Juan Cabezon of Castile* (1992).

Baker, Robert B. Contemporary photographer, teacher who recorded people's reactions at the Vietnam Veterans Memorial, Washington, D.C., and other places while he served in the U.S. Air Force during the 1980s.

Bazil, Frances. Native American who was a teenager when she won first prize for her poem "Uncertain Admission" at the National Indian Arts Exhibition, Scottsdale, Arizona, 1965.

Bergman, Miranda, and others, including Jane Norling, Vicky Hamlin, Maria Ramos, and Arch Williams. California artists who created public murals in the San Francisco area during the 1970s and 1980s.

Castellanos, Rosario (1925–1974). Mexican writer, professor, diplomat whose social concern, feminism, and strong sense of cultural identity are evident in her novels, short stories, and poems. *A Rosario Castellanos Reader* (1988) was published by the University of Texas Press.

Cervantes (Miguel de Cervantes Saavedra) (1547–1616). Spanish writer whose imaginary hero "Don Quixote" becomes more real to us when he dares to dream the impossible.

Chávez, César (Estrada) (1927–1993). California farm worker who made himself into a lasting symbol of human courage as he planted the seeds for a great harvest of justice and freedom.

Chávez, Eduardo (born 1917 in New Mexico). Artist, teacher who painted W.P.A. murals in Colorado, Nebraska, Texas, and Wyoming. His later work is found in collections throughout the U.S., including the Museum of Modern Art, New York, and the Hirshhorn Museum in Washington, D.C.

Clift, William Brooks, III (born 1944 in Massachusetts). Award-winning photographer who focuses on New York and New England, where he grew up, and New Mexico, where he has settled. Books include *Certain Places* (1987).

Cofer, Judith Ortiz (born 1952 in Puerto Rico). Prizewinning writer, teacher who now lives in Georgia. Her thought-provoking poems can be found in *Peregrina* (1986) and in the collection *Triple Crown* (1987).

Columbus, Christopher (Cristóbal Colón) (1451–1506). Controversial Italian navigator who hoped to find a direct westward route to the Indies, instead "discovered" and explored the Americas in a series of voyages, 1492–1504.

Cortés, Hernán (or Hernando) (1485–1547). Spanish "conquistador" who defeated the Aztecs and claimed Mexico for the kingdom of Spain.

Cunningham, Imogen (1883–1976). Known as "the grandmother of American photography," she was a pioneer of pictorialism on the West Coast. Wrote *After Ninety* (1977) and other illustrated books.

Davis, Nathaniel (born 1925 in Massachusetts). Diplomat, author who served as U.S. Ambassador to Guatemala, 1968–71; Chile, 1971–73; and other countries. Later became a college professor in California.

Delano, Jack (born 1914). Photographer who has captured the beauty of everyday life in Puerto Rico and elsewhere. Books of his photographs include *De San Juan a Ponce en el tren* (1990).

DeSiga, Daniel. Contemporary artist who lives in Seattle, Washington. Recently his work has been seen and admired in "Chicano Art," a traveling exhibition that is also the subject of a book.

De Villagrá, Don Gasper. Officer in the expedition that established "New Mexico," 1598, and brought the first Spanish settlers. He later returned to Spain, published an epic poem, *The True History of New Mexico* (1610).

Díaz del Castillo, Bernal (1496–1584). Soldier who came to the "New World" with Cortés in 1518 and wrote a detailed account of these adventures, *The Discovery and Conquest of Mexico* (1517–21).

Dillehay, Tom (born 1947 in Texas). University of Kentucky professor, anthropologist who has discovered in remote Chilean forests a variety of ancient tools, remains of food, and other traces of human activity from nearly 13,000 years ago. Books include *Monte Verde* (1989) and *The First Americans* (1991).

Duardo, Richard (born 1952). Los Angeles, California, printmaker whose work is featured in shows of Chicano art. His interest in "pop culture" has also led him to design record album covers for Jackson Brown and other groups.

Durán, Roberto (born 1953). California activist whose concern for justice is expressed both in his career as a social worker and in his poetry. *Reality Ribs* (1993) contains hard-hitting poems like those published in the collection *Triple Crown* (1987).

El Greco ("The Greek," Doménikos Theotokópoulos) (1541–1614). Artist born in Crete, moved to Spain, painted a number of religious masterpieces as well as two famous views of the city of Toledo, where he lived for more than thirty years.

Espada, Martin (born 1957 in Brooklyn, New York). Lawyer who fought for the rights of low-income tenants in Boston; also a prizewinning poet, now teaching at the University of Massachusetts–Amherst. Books include *Trumpets from the Islands of Their Eviction* (1987) and *City of Coughing and Dead Radiators* (1993).

Esteves, Sandra María (born about 1955). New York City author whose writing often crosses the border between Spanish and English; her publications include a book of poetry, *Bluestown Mockingbird Mambo* (1990).

Flax, Hjalmar (born 1942). Puerto Rican author, movie critic; poetry books include *Los pequeños laberintos / The Small Labyrinths* (1978) and *Tiempo adverso / Time of Adversity* (1982).

Florez, John (born c. 1937 in Utah). Social worker, university professor, government administrator with a distinguished record of public service; in 1991–92 served as executive director of the President's Advisory Commission on Educational Excellence for Hispanic Americans.

Fonseca, Harry (born 1946 in California). Artist who works mostly in mixed media on canvas; designed a bright, eye-catching logo for the Coyote Cafes located in Santa Fe, New Mexico, and elsewhere.

Frost, Robert (1874–1963). Four-time winner of the Pulitzer Prize for poetry; born in San Francisco, lived mostly in New England, traveled to Florida and other places; gradually reached a worldwide audience with his wise and witty verses. (The "Culebra Cut" in his poem refers to the big ditch dug for the Panama Canal.)

Galarza, Ernesto (1905–1984). Mexican-American author whose *Barrio Boy* (1971) is both an autobiographical novel about one young person growing up and a story that applies to all people in similar circumstances. Also wrote *Mexican Americans in the Southwest* (1969) with Herman Gallegos and Julian Samora.

Galván Rodríguez, Odilia. California writer, political activist since age fifteen. She grew up in Chicago, in summers lived with relatives who came north to work in the fields; thus she learned about the problems of migrant laborers.

Galvez, Daniel (born 1953). California artist who tries to find "the deepest expressions of Raza consciousness," to encourage Hispanic Americans to be more proud of their cultural heritage, and to inspire people to greater achievements.

Gandert, Miguel A. (born 1956). New Mexico photographer, teacher, also engaged in film and video production; his work has been seen at the Smithsonian Institution, Washington, D.C., and in other national and international exhibitions.

Garcia, Antonio E. (born 1901 in Mexico). Grew up in Texas, learned to paint, created murals at various churches and public buildings; later he worked as a college art teacher, also as a book and magazine illustrator.

García, Mario T. (born 1944). Professor, author of scholarly books including *Desert Immigrants: The Mexicans of El Paso, 1880–1920* (1981), *Mexican Americans* (1991), and *Memories of Chicano History* (1994).

Garcia, Rupert (born 1941). California artist who uses his talents to make striking posters for the social movements he believes in, such as civil rights, land rights, and "La Causa," the labor struggle of farm workers.

Geada, Rita (born 1937 in Cuba). Poet who moved to the U.S., now teaches at Southern Connecticut State College; she is known to English-speaking magazine readers in the U.S. and abroad, but her impassioned books, such as *Mascarda* (1970) and *Vertizonte* (1977), have not been translated from Spanish.

Gómez-Peña, Guillermo (born c. 1950 in Mexico). California artist, author; in 1984 he cofounded the Border Art Workshop (near San Diego/Tijuana) to specialize in the two cultures. Author of *Made in Aztlán: Centro Cultural de Raza* (1987) with Philip Brookman and *Warrior of gringostroika* (1993), a volume of poetry.

Gonzales, Rebecca (born 1946 in Texas). Teacher, poet who writes movingly about the everyday lives of South Texas people; books include *Cedar Rock* (1982) and *Slow Work to the Rhythm of Cicadas* (1985).

Gonzales, Rodolfo ("Corky") (born 1928). Poet who brought attention to the concept of "La Raza" in his book *I Am Joaquín/Yo soy Joaquín* (1972), an epic poem with a detailed chronology of Mexican and Mexican-American history.

González, Barbara Renaud (born c. 1960). Socially conscious poet who grew up in the Texas Panhandle, earned degrees at the University of Michigan and elsewhere, now lives in Dallas, works as a community development consultant.

González, Ray (born 1952 in El Paso, Texas). Award-winning Texas poet, author of *Twilights and Chants* (1987), *Memory Fever* (1993), and other books; editor of *After Aztlán: Latino Poets of the Nineties* (1992); also literature director of the Guadalupe Cultural Arts Center, San Antonio.

Groth-Kimball, Irmgard (c. 1920–1992). European photographer who became an expert on ancient sculpture and archaeology; illustrated books include *The Art of Ancient Mexico* (1954) and *Mayan Terracottas* (1961).

Guitart, Jorge (born 1937 in Cuba). Poet, professor at the State University of New York at Buffalo; has produced five scholarly books and a volume of insightful poems, *Foreigner's Notebook* (1993); also has edited *Terra Poetica*, a multilingual poetry magazine.

Handelsman, J. B. (born 1922 in New York). Cartoonist whose work has been published in *The New Yorker* and other magazines. His humorous books include *Freaky Fables* (1984) and *Further Freaky Fables* (1986).

Hogue, Alexandre (born 1898 in Missouri). Leading regional artist in Dallas, Texas, who helped to open the doors to art from south of the border; later he embraced modernism, taught art at the University of Tulsa, 1945–68, before retiring.

Hollyman, Tom (born 1919 in Colorado). Photojournalist whose coverage of unusual people and places has appeared in the original *Holiday*, later in *Town and Country*, and other leading magazines. Illustrated books include the bilingual *America 1492–1992*, published in Colombia.

Huidobro (Fernandez), Vicente Garcia (1893–1948). Chilean writer whose work, written mostly in French, became better known in books issued after his death, such as *Selected Poetry* (1981), *Altazar* (1988), and *The Poet Is a Little God* (1990).

Hurd, Peter (1904–1984). Artist born in New Mexico who enjoyed raising cattle, painting ranch and rural landscape scenes as he saw them, and writing journals published in *My Land Is the Southwest* (1983) and other books. (José Herrera was his ranch foreman in Montana.)

Jackson, William Henry (1843–1942). Photographer whose early studies of Sante Fe, Yellowstone National Park, Mesa Verde National Park, Four Corners, and other areas are found in many important collections today.

Jimenez, Luis (born 1940 in Texas). Artist who moved to New Mexico, became known for large, brightly colored sculptures of fiberglass and epoxy, says, "I give form to my culture's icons." His work is seen often in art exhibitions and cultural centers such as the National Museum of American Art, Washington, D.C.

Jodorowsky, Raquel (born 1927 in Chile). Peruvian poet, teacher, widely published in Latin America but little known in the U.S.; she also became a successful painter in later years. Books include *Sin antes ni después* (1984).

Kahlo, Frida (1907–1954). Born in Mexico, studied art there, married Diego Rivera in 1929, visited San Francisco

and other U.S. cities with him in the 1930s. First U.S. exhibition of her paintings in New York, 1938. Gradually recognized as an artist of great individuality and imagination, she is now world famous.

Lam, Wifredo (Wifredo Oscar de la Concepción Lam y Castillo) (1902–1982). Born in Cuba. Visited Europe, later settled in Paris. Strongly influenced by Matisse and Picasso and (as they were) by African art, but developed his own distinctive style and became a favorite of modern art collectors and museums.

Larraz, Julio (born 1944 in Cuba). Started painting in New York during the 1960s, now lives in Miami. His still lifes, landscapes, and figurative works, featured in several exhibitions and collections, are not as "realistic" as they first appear to be.

Lastra, Pedro (born 1932 in Chile). Professor of Spanish, State University of New York at Stony Brook; literary critic; author of more than a dozen volumes of thoughtful poetry, including *And We Were Immortal* (1969) and *Notebook of the Double Life* (1984).

Leal, Fernando (1900-1964). Mexican artist, author, who also taught and directed an art school. Starting with murals in the 1920s, he produced a variety of notable work, including illustrated books, and wrote *The Rites of Culture* (1952).

Lee, Russell (1903–1986). One of several outstanding photographers who came to attention through their documentary pictures for the Farm Security Administration, 1935–43, because of the depressed conditions they recorded in the Southwestern U.S. and elsewhere.

Leifer, Neil (born c. 1930). Photographer whose live-action shots have been published in magazines such as *Sports Illustrated* and collected in *Sports* (1978) and other books.

Lester, William (born 1910 in Texas). Artist whose early work includes sketches of everyday life in Dallas. Later he became more interested in design and color than in actual representation, produced forceful landscapes of rural Texas.

Lima, Roberto (born 1935 in Cuba). Poet, critic, scholar, translator who has lived in Peru and Mexico; now professor of Spanish and comparative literature at Pennsylvania State University. His poetry deserves more attention.

Linares, Miguel. Contemporary artist whose work embodies the cultural traditions and colorful folkways of his native Mexico.

Lomas Garza, Carmen (born 1948). California artist whose fanciful paintings, prints, and paper cutouts sometimes recall her earlier experiences as a Chicana growing up in South Texas.

Lopez, Alonzo (born c. 1950). Native American poet who first gained recognition at the Institute of American Indian Arts, Santa Fe, New Mexico.

Maia, Circe (born 1932 in Paraguay). High school teacher who has published five books of poetry in Uruguay, such as *Cambios, permanencias* (1990). Her direct, open, conversational writing style brings the daily world alive with great intensity.

Martinez, Emanuel (born 1947). Colorado artist who uses many forms and concepts from his *mestizo* background in an attempt to preserve tradition and cultural values, while celebrating the wonders of being human.

MartinNez, Dave. Native American who learned to write poetry as a young man at the Institute of American Indian Arts, Santa Fe, New Mexico, during the 1960s.

Matta (Echaurren), Roberto (Sebastian Antonio) (born 1911 in Chile). Artist who traveled extensively, lived in the U.S., 1939–47, before moving to Rome, Italy. His widely respected work is seen at exhibitions and art museums in New York, San Francisco, and elsewhere.

McIlroy, Kevin (born 1953 in Illinois). Teaches writing at New Mexico State University; editor of the magazine *Puerto Del Sol;* author of *The Fifth Station* (1989), a novel based on two brothers' love of the land.

Medellin, Octavio (born 1907 in Mexico). Moved to San Antonio in 1920. Sculptor whose powerful work is carved directly in stone or wood. Featured at the Museum of Modern Art, New York, 1942, and various other museums. Taught at U.S. universities before starting his own School of Sculpture in 1966.

Medina, Luis (1942–1985). Born in Cuba. Came to Miami in 1958, later moved to Chicago where he worked at the Art Institute, specialized in sharp-edged photographs of gangs, outcasts, graffiti, and other current features of urban life.

Miller, Mark Charles (born 1949). Famous for "hot" recipes in Santa Fe, New Mexico, and other cities; author of *Coyote Cafe: Foods from the Great Southwest* (1989) and several other collections, including *The Great Chile Book* (1991) with John Harrison.

Mohr, Nicholasa (born 1935). Born and grew up in New York City; a well-regarded artist who has also written books for children and adults, including *Nilda* (1973), *El Bronx Remembered* (1975), *Felita* (1979), and *Going Home* (1986).

Montoya, Malaquias (born 1938 in Albuquerque, New Mexico). Artist, teacher now living in California. His silk-screen prints speak of impassioned protest, the struggle against injustice, and other political aspects of contemporary life.

Mora, Pat (born 1942 in El Paso, Texas). Lives in Ohio. Poet who received a Kellogg National Fellowship, author of *Chants* (1984), *Borders* (1986), *Communion* (1991), and stories for children, such as *Pablo's Tree* (1994).

Mosquera, Gerardo. Cuban writer, curator, authority on Cuban art. Wrote *Exploraciones en la plastica cubana* (1983), *Con la primera cantante* (1984), and *The Cultural Policy of Cuba* (1979), with Jaime Saruski.

Nahoum, Ken (born c. 1965). Lives in New York. Photographer who provides *Rolling Stone* and other publications with striking shots of the latest fashions and those who wear them.

Neri, Manuel (born 1930 in California). Award-winning sculptor, professor of art at the University of California, Davis. Well known on the West Coast for his sensuous, innovative work in plaster, more recently in marble; deserves wider recognition as a truly creative artist.

Noe, Luis Felipe (born 1933 in Buenos Aires). Artist who returned to Argentina after a long exile in Paris. His writings complain of discrimination against art from Latin America, but in fact his paintings have been seen and enjoyed at major art exhibitions in the U.S.

O'Keeffe, Georgia (1887–1986). Born in Wisconsin but fell in love with the Southwest after living in Texas, 1912–18. She developed a unique style of painting in the 1920s, full of color and "magical realism" yet almost abstract, which did not at first catch on. Now highly regarded, her work is eagerly sought by private collectors and museums all over the world.

Orozco, José Clemente (1883–1949). Born in Mexico, frequently visited the U.S., lived in New York City, 1927–34. His dynamic paintings have been prominently displayed at leading museums in New York, San Francisco, Washington, D.C., Boston, and other cities.

Paz, Octavio (born 1914). Mexican diplomat, writer; winner of the Nobel Prize for Literature, 1990. Among many other books, the bilingual *Collected Poems* (1987) shows the splendid development of his work over the years. Also of interest: *Essays on Mexican Art* (1993).

Pérez-Firmat, Gustavo (Francisco) (born 1949 in Cuba). Moved to Miami in 1960. Earned a Ph.D. at the University of Michigan. Critic, professor of Spanish language and literature at Duke University, author of *The Cuban Condition* (1989), but above all a poet who writes movingly about his ties to other places, other times.

Picasso, Pablo (1881–1973). Born in Spain, lived mostly in France, became universally famous as one of the most innovative and influential artists of all time. A man of humble origins but much pride, he longed to see his paintings hanging in museums, among the works of the great masters, and now they are.

Piri, Thomas (born c. 1930). Author of a children's book, *Stories from el Barrio* (reissued 1992), as well as the classic novel of Puerto Rican life in New York City, *Down These Mean Streets* (1967).

Quintana, Leroy V. (born 1944 in New Mexico). Vietnam War veteran, award-winning poet, professor of English at San Diego Mesa College; his colorful books include *Hijo del Pueblo: New Mexico Poems* (1976), *Sangre* (1981), *The Reason People Don't Like Mexicans* (1984), and *The History of Home* (1993).

Ramos, Joe B. (born 1949). California photographer whose work is featured in exhibitions of Chicano art and culture; he has a great gift for seeing people as they would like to be seen.

Rickerby, Arthur (c. 1910–1972). Photographer who traveled to exotic places for Time, Inc. Also took pictures for *A Special Report on the Rockefeller Foundation's Program Toward Equal Opportunity for All* (1965).

Rivera, Diego (1886–1957). Mexican artist who often visited the U.S. with his wife, Frida Kahlo. Gained early fame for the "social realism" of murals he created during the

1920s and 1930s in Mexico City, New York, San Francisco, and elsewhere. More recently has won acclaim for his "portraits" of ordinary people and everyday life, which are in numerous museum collections.

Rivera, Francis (born c. 1955). Lives in Albuquerque, New Mexico. Painter, muralist who deals with both contemporary and regional themes; also gives lectures and teaches art.

Rivera, Tomás (1935–1984). Bilingual author of the classic novel *. . . y no se lo trago la tierra / . . . and the earth did not devour him* (1976). This and later writings can be found in Rivera's *Complete Works* (1991), edited by Julián Olivares.

Rojas, Gonzalo (born 1917 in Chile). Leading writer and diplomat who traveled extensively and lived in Cuba and China. Eleven of his books have been published, most recently the bilingual *Schizotext & Other Poems/Esquizo-texto y Otros Poemas* (1988).

Romero, Orlando (Arturo) (born 1945). Author, research librarian at the Museum of New Mexico. His highly praised novel *Nambe–year one* (1976) is named after the Indian pueblo and village near Sante Fe, where he lives on land deeded to his family more than 200 years ago.

Roosevelt, Theodore (1858–1919). Born in New York. 26th president of the U.S., 1901–9. In addition to being a war hero and successful politician, he was also an author, explorer, environmentalist, and winner of the Nobel Peace Prize, 1906, for helping to end the Russo-Japanese War.

Sabina, Maria (c. 1900–1985). Medicine woman of the Mazatec Indians, Mexico, she created chants (resembling both songs and poems) that others have translated from her people's language into Spanish and English.

Salazar, Rubén (1928–1970). Born in Mexico, moved to California. Influential journalist who wrote about Chicano subjects in *The Los Angeles Times* and other newspapers; also worked as a television news director.

Salazar Tamariz, Hugo (born 1923 in Ecuador). Author who became active in the national movement of Ecuadorian writers. Among other works, he wrote a book of verse, *3 i.e. Tres poemas* (1968) and *Teatro* (1986), a volume of plays.

Salgado, Sebastião (born 1944 in Brazil). Socially conscious photographer who has searched the world to find the most compelling images of workers and their families. Books include *Other Americas* (1986), *An Uncertain Grace* (1990), and *The Best Photos* (1992).

Salinas, Luis Omar (born 1937). California writer whose powerful early work, hard to find, can now be enjoyed in *Sadness of Days: Selected & New Poems* (1987). Also he has edited *From the Barrio: A Chicano Anthology* (1973).

Samuel, William G. M. (1815–1902). Self-taught artist, born in Missouri, moved to Texas in the 1830s, became a painter of local scenes and people, later a sheriff.

Sandlin, Lisa (born c. 1960). Author of *The Famous Thing about Death & Other Stories* (1991), she grew up in Texas, moved to New Mexico where her grandparents had journeyed in a mule-drawn wagon. A dancer, too, she calls *flamenco* "an astonishing art form, full of sorrow and grace."

Sargent, John Singer (1856–1925). Outstanding portrait artist who occasionally created a larger masterpiece, such as *El Jaleo* (1882), inspired by a trip to Spain. This painting, from the Isabella Stewart Gardner Museum in Boston, was featured in a special show at the National Gallery of Art, Washington, D.C., in 1992.

Strand, Paul (1890–1976). A master of the "straight" photograph who believed that objectivity was the highest goal of his profession. Books that show his photographs from all parts of the world include *The Transition Years: Paul Strand in New Mexico* (1990).

Tafolla, Carmen (born 1951 in Texas). Starting in the barrio schools of San Antonio, she went on to earn a Ph.D. in bilingual education. A dedicated teacher who writes poetry, high school textbooks, and screenplays for children's Spanish-English television programs. Named an Outstanding Young Woman of America, 1976–77.

Tamayo, Rufino (1899–1991). Mexican figurative artist who lived in the U.S., 1936–51. Moved to Paris before returning to Mexico. He gained worldwide fame for his strongly drawn, deeply colored murals and paintings, which can be seen at major museums in New York, Washington, D.C., and elsewhere.

Thomas, Anita Gonzáles (born c. 1940). Scholar who has done extensive research on the traditional folk dances of the Southwest; her publications include *Music of the Bailes in New Mexico* (1978), a book of fiddle tunes.

Toledo, Francisco (born 1940 in Mexico). Increasingly well known painter, graphic artist, and sculptor. Visited the U.S. in the 1970s, now lives mostly in Mexico and Paris.

Torres, Salvador Roberto (born 1936). California artist whose paintings reflect a combination of Mexican and American cultures. He is inspired by the spiritual ideas and realities of "La Raza," and by other Chicano artists striving for social justice.

Torres-García, Joaquín (1874–1949). Born in Montevideo, Uruguay. Prolific writer, artist who studied and worked in Europe, later lived in New York City, 1920–22. His distinctive oil paintings can be found at the Museum of Modern Art, New York, the Solomon R. Guggenheim Museum, and other cultural institutions.

Tufiño, Rafael (born 1922 in Brooklyn, New York). Studied art in Puerto Rico and in Mexico City, gained recognition for his strong portrayals of people at work. His pictures are in the collection of the Museum of Modern Art, New York, and others.

Utibarrí, Sabine R. (born 1919 in New Mexico). Writer, scholar, who became professor and head of the department of modern and classical languages at the University of New Mexico. Books include *Tierra Amarilla El condor* and five other collections of stories in Spanish and English.

Vespucci, Juan. Sixteenth-century Florentine ship's pilot, mapmaker, nephew of Amerigo Vespucci, who gave his name to the Americas.

Vitier (y Bolanos), Cintio (born 1921 in Key West, Florida). Prolific author whose work includes *Temas Martianos* (1981), written with Fina Garcia, in addition to a volume of essays, two anthologies of Cuban poetry, and his own *Poemas de mayo y junio* (1990).

Warren, Nancy Hunter. Staff photographer at the Museum of New Mexico in Santa Fe since 1974, she has been accepted into Hispanic communities and allowed to take photographs of scenes seldom shared with outsiders. Author of many magazine articles and two illustrated books, *New Mexico Style* (1986) and *Villages of Hispanic New Mexico* (1987).

Whistler, James McNeill (1834–1903). Born in Massachusetts, moved to England in 1859. Highly talented artist who loved a good argument as much as a good painting. His innovative "nocturnes" and other works were considered radical at first, but they are now seen as masterpieces.

Whitman, Walt (1819–1892). Born in New York. Recognized as a major poet with *Leaves of Grass* (1855), which he revised from time to time as he learned more and more about the America he loved.

Wilkens, Mike (born 1959 in Texas). Received his M.B.A. from Stanford University; now based in San Francisco. His ventures to date include music, art, investment banking, and script-writing for television and movies.

List of Illustrations

19⅞ × 34″. Private collection. Photo: Courtesy Mary-Anne Martin Fine Art, New York. Page 55: Francis Rivera. *Mural at Longfellow Elementary School, Albuquerque, New Mexico* (detail). 1983. © Francis Rivera. Photo: Miguel Gandert. Page 56: Alexandre Hogue. *Art of the Americas, Pre-Columbian and Contemporary.* 1937. Catalogue cover illustration. Getty Center for History of Art and the Humanities, Santa Monica, California. Photo: Scott Bauer, New York. Page 57: Lawson Blackmond. *Octavio Medellin in his Studio.* c. 1938. Reproduced with permission of Octavio Medellin. Page 58: José Clemente Orozco. *Los Muertos (Skyscrapers).* 1931. Oil on canvas, 43 × 36″. El Instituto Nacional de Bellas Artes y Literatura, Mexico City. Photo: Bob Schalkwijk, Mexico City; © INBA. Page 59 top: Joaquín Torres-García. *Constructive Composition.* 1931. Oil on canvas, 37⅜ × 24″. Solomon R. Guggenheim Museum, New York. Gift, Royal S. Marks in memory of Gertrude Marks and Herbert F. Gower, Jr., 1987. Photo: David Heald © The Solomon R. Guggenheim Foundation, New York. ARS, New York. Page 59 bottom: Francisco Toledo. *Flying Tiles.* c. 1965. Gouache on Arches, 22¼ × 29¼″. Private collection. Photo: Sarah Wells/Courtesy Mary-Anne Martin Fine Art, New York. Page 60: William H. Jackson. *Oldest House in Santa Fe, New Mexico.* c. 1881. Photograph. Courtesy Museum of New Mexico, Santa Fe #49170. Page 61 top: Neil Leifer. *Roberto Clemente at Bat.* 1960s. Photograph. Page 61 bottom: Arthur Rickerby. *Ancient Stone Figures in the Andes.* Photograph. © 1965 Time-Life Books, Inc. Page 62: Wifredo Lam. *The Jungle.* 1943. Gouache on paper mounted on canvas, 7′ 10¼″ × 7′ 6½″. Collection, The Museum of Modern Art, New York. Inter-American Fund. Page 65 left: Julio Larraz. *The Thief.* 1985. Oil on canvas, 51 × 59″. Westinghouse Electric Corporate Art Collection, Pittsburgh. Photo: Lee Averback. Page 65 right: Manuel Neri. *Chula.* c. 1958–60. Plaster and pigment, 46 × 14 × 16½″. San Francisco Museum of Modern Art. Partial gift of Mary Heath Keesling. Photo: Don Myer. Page 66: *West Side Story, Playbill* cover. 1957. PLAYBILL® covers printed by permission of PLAYBILL Incorporated. PLAYBILL® is a registered Trademark of PLAYBILL Incorporated, New York. Page 67: Cover illustration of Ernesto Galarza's *Barrio Boy.* From *Barrio Boy* by Ernesto Galarza. © 1971 by University of Notre Dame Press. Reprinted by permission of the publisher. Pages 68–69: Juan Vespucci. *Manuscript Map of the World.* Seville, 1526. Ink and watercolor on parchment, 34⅞ × 105⅞″. Courtesy of The Hispanic Society of America, New York. Page 70: Luis Medina. *Sons of the Devil.* 1980–84. Silver dye bleach print, 10¾ × 10¼″. Courtesy of The Art Institute of Chicago. Chicago Portfolio Fund, 1990.597.3. Photo: © 1993 The Art Institute of Chicago. All Rights Reserved. Page 72: Daniel DeSiga. *Campesino.* 1976. Oil on canvas, 50½ × 58½″. Collection of Alfredo Aragón. Photo: Courtesy Wight Art Gallery, UCLA, Los Angeles. Page 73: *Tortilla Molds.* 1930s. Vizarrón, Querétaro, Mexico. Carved wood, approx. 10 × 2″. Mexico Museum, San Francisco, and San Antonio Museum of Art, Texas. Nelson A. Rockefeller Collection. Page 74: William Lester. *Little Mexico.* 1930. Lithographic crayon on paper, 8⅛ × 7⅜″ (image). Dallas Museum of Art, Dallas Art Association purchase. Page 75: Rafael Tufiño. *Cortador de Caña (Cane Cutter).* 1951–52. Linocut on paper, 11½ × 18½″. Museum of History, Anthropology and Art of the University of Puerto Rico. Photo: John Betancourt, San Juan. Page 77: Frida Kahlo. *Self-Portrait with Cropped Hair.* 1940. Oil on canvas, 15¾ × 11″. Collection, The Museum of Modern Art, New York. Gift of Edgar Kaufman, Jr. Photo: Mali Olatunji; © 1992 The Museum of Modern Art, New York. Page 78: Russell Lee. *We Serve White's Only.* 1949. Photograph. Russell Lee Photograph Collection, The Center for American History. The University of Texas at Austin. Page 80: Harry Fonseca. *Coyote Cafe* (logo). 1980. Art by Harry Fonseca. Used by permission from Coyote Cafe, Ltd., Santa Fe, New Mexico. Page 82: Emanuel Martinez. *Farm Workers' Altar.* 1967. Painted wood, height: 4′. National Museum of American Art, Washington, D.C./Art Resource, New York. Page 83: Miranda Bergman, Jane Norling, Vicky Hamlin, Maria Ramos, Arch Williams. *Educate to Liberate* (detail). 1988. Novacolor acrylic on concrete. Photo: James Prigoff. Page 85: Rufino Tamayo. *El Hombre (Man).* 1953. Vinyl with pigment on panel, 18′ × 10′6″. Dallas Museum of Art, Dallas Art Association commission, Neiman-Marcus Company Exposition Funds. Page 86: Imogen Cunningham. *Mendocino Motif.* 1959. Photograph, 8 × 10″. The Imogen Cunningham Trust, Berkeley. © The Imogen Cunningham Trust. Page 89: Georgia O'Keeffe. *Black Cross with Red Sky.* 1929. Oil on canvas, 40 × 32″. Collection Mr. and Mrs. Gerald Peters, Santa Fe, New Mexico. Copyright © 1993 The Georgia O'Keeffe Foundation/ARS, New York. Page 90: William Clift. *Car, Shiprock, New Mexico.* 1975. Photograph. © William Clift. Page 93: Miguel Linares. *Skeleton Vendor.* Mid 1970s. Mexico, D.F. Paper, wood, wire, and paint, 36 × 19 × 14″. San Antonio Museum of Art, Texas. Nelson A. Rockefeller Collection. Photo: Lee Bolton. Page 94: Ken Nahoum. *Gloria Estefan.* 1990. Photograph. © Ken Nahoum. Page 97: Fernando Leal. *The Boxer.* 1924. Oil on canvas, 21⅞ × 16″. Collection Fernando Leal Audirac. Photo: Jesús Sánchez Uribe. Page 98: Jack Delano. *Graduation Day at the University of Puerto Rico at Río Piedras.* 1980. Photograph, 11 × 14″. Courtesy of the artist. © Jack Delano, San Juan. Page 99: Photograph of John Florez. From *Saludos Hispanos Magazine,* April/May 1992. Used with permission of the magazine. Page 100: Mike Wilkens. *Preamble.* 1987. Painted metal on vinyl and wood, 8′ × 8′. National Museum of American Art, Smithsonian Institution, Washington, D.C. Gift of Nissan Motor Corporation/Art Resource, New York. Page 102: Richard Duardo. *Aztlán.* 1982. Silkscreen, 25¼ × 38″. Collection of Shifra M. Goldman. Photo: Courtesy Wight Art Gallery, UCLA, Los Angeles. Page 104: Salvador Roberto Torres. *Viva La Raza (Long Live Humanity).* 1969. Oil on canvas, 53 × 42″. Collection of the artist. Photo: Courtesy Wight Art Gallery, UCLA, Los Angeles.

Acknowledgments

Grateful acknowledgment is made for permission to reproduce the poems, songs, and text excerpts by the following writers. All possible care has been taken to trace ownership of every selection included and to make full acknowledgment. If any errors or omissions have occurred, they will be corrected in subsequent editions, provided that notification is sent to the publisher.

Rudolfo A. Anaya, excerpt from *Heart of Aztlán.* © Rudolfo A. Anaya, 1976, distributed by the University of New Mexico Press, Albuquerque. Reproduced with permission of the author. Anonymous, "Five Hundred Steers There Were," excerpt from folk song, in *A Texas-American Cancionero: Folksongs of the Lower Border,* University of Illinois Press, Urbana, 1976. Homero Aridjis, "Encounter," from *Anthology of Contemporary Latin American Literature 1960–1984,* ed. Luby and Finke. Fairleigh Dickinson University Press. Copyright 1986 Associated University Presses. Frances Bazil, "Uncertain Admission," from *Anthology of Poetry and Verse, 1965.* Published by permission of the Institute of American Indian Arts, Santa Fe, New Mexico. All rights reserved. Rosario Castellanos, "Empty House" and "Silence Near an Ancient Stone," from *Woman Who Has Sprouted Wings: Poems by Contemporary Latin American Women Poets.* Reprinted by permission of the publisher, Latin American Literary Review Press, 1988, Pittsburgh. César Chávez et al., excerpt from "The Plan of Delano," in *Aztlán: An Anthology of Mexican American Literature,* eds. Luis Valdez and Stan Steiner. Alfred A. Knopf, New York, 1965. Judith Ortiz Cofer, "Crossings," "The Habit of Movement," "Lesson One: I Would Sing," "On the Island I Have Seen," and "The Other," from collection *Reaching for the Mainland* appearing in *Triple Crown,* 1987, Bilingual Press, Arizona State University, Tempe. Reprinted with permission of the publisher. Christopher Columbus, excerpt from his letter to the king and queen of Spain, from *The Four Voyages of Christopher Columbus,* Cresset Press, 1969. Nathaniel Davis, excerpt from "United Fruit Is Not Chiquita," reprinted by permission from NACLA Report on the Americas V. 5, no. 6, Oct. 1971. Copyright © 1971 by North American Congress on Latin America, 475 Riverside Drive, New York. Bernal Díaz del Castillo, excerpt from *The Discovery and Conquest of Mexico* by Bernal Díaz del Castillo. Copyright © 1956 by Farrar, Straus & Cudahy. Copyright renewed © 1984 by Farrar, Straus & Giroux, Inc. Reprinted by permission of Farrar, Straus & Giroux, Inc. Roberto Durán, "Border Towns," "Color," and "Trendy Categorization," from the collection *Feeling the Red on My Way to the Rose Instead* in *Triple Crown,* 1987, Bilingual Press, Arizona State University, Tempe. Reprinted with permission of the publisher. Martin Espada, "We Live by What We See at Night," from *Being América: Essays on Art, Literature, and Identity from Latin America,* ed. Rachel Weiss, White Pine Press, 1991. Sandra María Esteves, excerpt from "Not Either," in *Tropical Rains,* 1984. Used with permission of the author. Hjalmar Flax, "Advanced Course" and "Love or Cult," from *Anthology of Contemporary Latin American Literature 1960–1984,* ed. Luby and Finke. Fairleigh Dickinson University Press. Copyright 1986 Associated University Presses. John Florez, excerpt from speech, from "John Florez: Role Model" by Jonathan J. Higuera for *Saludos Hispanos* magazine, April / May 1992. Robert Frost, "America Is Hard to See," from *The Poetry of Robert Frost,* ed. Edward Connery Lathem. Copyright © 1969 by Holt, Rinehart and Winston. Copyright 1951, © 1962 by Robert Frost, Reprinted by permission of Henry Holt and Co., Inc. Ernesto Galarza, from *Barrio Boy,* © 1971 by University of Notre Dame Press. Reprinted by permission of the publisher. Odilia Galván Rodríguez, "Migratory Birds" and "Muralist." Copyright © Odilia Galván Rodríguez. Originally appeared in *New Chicano / Chicana Writing I,* ed. Charles Tatum. The University of Arizona Press, 1992. Mario T. García, excerpt from *Desert Immigrants: The Mexicans of El Paso, 1880–1920.* Yale University Press, New Haven, Connecticut. Reprinted by permission of the publisher. Rita Geada, "Give Me Back My World," from *Woman Who Has Sprouted Wings: Poems by Contemporary Latin American Women Poets.* Reprinted by permission of the publisher, Latin American Literary Review Press, 1988, Pittsburgh, and "So That They Will Burn," reprinted by permission of the publisher, Latin American Literary Review Press, 1988, Pittsburgh. Guillermo Gómez-Peña, excerpt from essay "Documented / Undocumented" in *Graywolf Annual Five,* 1988, and "Mexico Is Sinking" in *High Performance,* #35, 1986. Rebecca Gonzales, "South Texas Summer Rain," Prickley Pear Press: Fort Worth, Texas, 1985. Reprinted with permission of the author. Ray Gonzáles, "The Energy of Clay," copyright 1991 by Ray Gonzáles. Used by permission of the author. Rodolfo "Corky" Gonzales, "La Raza!," from *I Am Joaquín,* Denver, 1967. Barbara Renaud González, "The Summer of Vietnam," from *New Chicano / Chicana Writing,* 1992, University of Arizona. Reprinted with permission of the author. Jorge Guitart, excerpt from "Buffalo," in *Anthology of Contemporary Latin American Literature 1960–1984,* ed. Luby and Finke. Fairleigh Dickinson University Press. Copyright 1986 Associated University Presses. Vicente Huidobro, "Emigrant to America," from *12 Spanish Poets,* ed. H. R. Hays, Beacon Press, Boston. Copyright 1943 by H. R. Hays; copyright renewed 1971 by H. R. Hays. Permission granted by the Estate of H. R. Hays. Raquel Jodorowsky, "The Power of Man," from *Woman Who Has Sprouted Wings: Poems by Contemporary Latin American Women Poets.* Reprinted by permission of the publisher, Latin American Literary Review Press, 1988, Pittsburgh. Pedro Lastra, "Drawbridges," from *Anthology of Contemporary Latin American Literature 1960–1984,* ed. Luby and Finke. Fairleigh Dickinson University Press. Copyright 1986 Associated University Presses. Roberto Lima, "Civil War: Spain," from *Anthology of Contemporary Latin American Literature 1960–1984,* ed. Luby and Finke.

Index

Page numbers in *italics* refer to illustrations.